HIDDEN CITIES

Marie
To my companion explorer
of the world and
our back yard
Love
Dave
Xmas '91

HIDDEN CITIES

Art & Design in Architectural Details
of Vancouver & Victoria

Text and Photographs by
Gregory Edwards

Talonbooks 1991

HIDDEN CITIES

Typeset by Gregory Edwards at Talonbooks
Printed and bound in Canada by Hignell Printing Limited, Winnipeg

Published by Talonbooks
201-1019 East Cordova Street,
Vancouver, B.C.
Canada, V6A 1M8

Published with assistance from the Canada Council

Canadian Cataloguing in Publication Data

 Edwards, Gregory.
 Hidden cities

ISBN 0-88922-287-8

 1. Decoration and ornament, Architectural—British Columbia—Vancouver—
History. 2. Decoration and ornament, Architectural—British Columbia—Victoria—
History. 3. Historical buildings, Architectural—British Columbia—Vancouver. 4.
Historical buildings, Architectural—British Columbia—Victoria.
I. Title.
NA3513.V3E38 1991 720'.9711'33 C91-091443-5

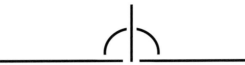

This book is dedicated to the appreciation
and preservation of fine architecture, and
to those visionary architects, developers
and sculptors who would give us beautiful
new buildings worth preserving.

I would like to acknowledge the assistance, advice, encouragement and inspiration provided to me by many individuals and organisations in the creation of this book. Among them I would like to thank Larry DeFehr, Ron Braunagel, David Stone, Peggy Imredy, Jim Bridge, Rxoachz, Barry Pinkerton, Melanie Robinson, Jill Mandrake, Constance Brissenden, Kellie Hampton, Phil & Becky Cotterell, and Leila. I am also indebted to the staff of the Public Library of Vancouver, the Public Library of Victoria, the Library of the B.C. Provincial Legislature, and the Vancouver City Archives.

The printer's ornaments are reproduced from "A Pictorial Archive of Printer's Ornaments," by Carole Belanger Grafton, 1980, courtesy of Dover Publications, 31 East 2nd Street, Mineola, New York, U.S.A. 11501.

Table of Contents

Introduction

Hidden Cities

There are lions, dragons, gods, goddesses, gargoyles and historical figures inhabiting an unexplored landscape in the *Hidden Cities* of Vancouver and Victoria. Cast in metal, carved in stone, formed in concrete or fired terra cotta clay, the architectural ornaments on the original buildings of these two cities reveal many fascinating social, cultural, and historical aspects of British Columbia's heritage. Some of these fascinating creations make a connection with legends and traditions which date back thousands of years. Hidden by the shadows of newer buildings, the glow of signs, and the suspended tangle of telephone and trolley wires, they await discovery on heritage buildings spanning architectural styles from Classical to Romanesque, Gothic, and Art Deco. While some of the buildings they embellish are highly regarded for their architectural qualities, these sculptures lack the setting and spotlights of an art gallery to distinguish them and reveal their artistic merit. Many are of uncredited origin, though in some cases the architects, or their associates, were responsible for the designs. The few full-time artists employed by contract for architectural details are not widely recognized for their creations.

"It is not enough merely to build a clean, healthful, orderly, smooth-functioning urban organism, although every agency of government should strive toward this end. In every possible way it must erase from the mind of the city dweller the monotony of daily tasks, the ugliness of factories, shops and tenements and the fatigue of urban noises. It can do this by showing a decent regard for its appearance, and by various devices it must occasionally touch the emotions. The city becomes a remembered city, a beloved city, not by its ability to manufacture or sell, but by its ability to create and hold bits of sheer beauty and loveliness."

"The city should have many small park areas suitable for monument sites. They should terminate vistas, occupy commanding positions, have dominance over their surroundings, be permitted to tell their story without disturbance, make positive contributions to the adornment of the city. Traffic circles with shafts or fountains, plazas in front of schools, with pools and balustrades and walls carrying inscriptions or bas-reliefs, all such, when well done, add tremendously to the impressiveness of the city. More of the wealth which is created by the commerce and industry of Vancouver should go into these things. The culture and taste of the people are not well reflected by its current aspect."

From "A Plan for the City of Vancouver, 1929," prepared by Harland Bartholomew

and Associates for the Vancouver Town Planning Association.

Vancouver and Victoria share a parallel heritage in their architecture. Architects from Victoria figure, at least in the early days, in the design and development of not only Victoria, but much of Vancouver as well. The two cities are not much more than 100 years old. Victoria is the older, dating back to the start of colonial administration on the West Coast, the Fort constructed by Island administrator James Douglas in 1843, while Vancouver began with Gastown in the 1880's.

Victoria is a wonderful city for those possessed of heritage consciousness. It has a wealth of beautiful heritage buildings, some of them dating as far back as the 1860's. The City of Victoria realized long ago just how important its unique historical buildings are to the urban landscape. As Victoria derives a lot of revenue from tourism, it discovered early on that it must regard preservation and conservation as an investment rather than an expense, and any new structures must be carefully blended with existing ones. The Eaton's Centre has attempted to integrate its newer design elements with the existing architecture, incorporating the renovation of older buildings such as the Driard Hotel into the different purposes of its new building. There are no trolley bus wires here, the pace is slower, and a variety of interesting and enlightening architectural details can be seen in a highly concentrated area of the downtown core.

Despite a late start, and a devastating early fire, Vancouver has grown into the major Pacific city of Canada. Had the first Canadian transcontinental railway terminus been Victoria, as was originally planned, things could have been different. Yet, what began as a seaside clearing by a forest of towering fir trees only a century ago, is now a world city. Vancouver's growth outstripped Victoria's at the turn of the century, but that continual growth has had its consequences for the city's heritage.

Vancouver's West End now has very few of its original buildings left, and the downtown area has seen the destruction of many beautiful structures, replaced by faceless high-rise buildings, whose mirrored glass will have nothing of quality to reflect if this trend continues. The awareness of the

need for heritage conservation has saved a few treasures from destruction, but the demand for land in the inner city is so great as to pose a constant threat to heritage concerns. A measure of compromise has been seen in a few well executed renovations, such as the Sinclair Centre in Vancouver, but these have been exceptions. The appreciation of architecture is an abstract pleasure, a balance between practical concerns and the harmonies of solid and spatial geometry—characterized by Goethe as "frozen music." The contents of this book may reveal some other reasons for supporting the conservation of the valuable buildings we still have.

Both Vancouver and Victoria are mosaics of cultural identies. Different ethnic groups made different contributions to these cities, and this diversity has given them their flavour.

Before the arrival of primarily European colonists, the Native Peoples of British Columbia had created spectacular and sophisticated sculptural forms. The immense plenty of the forests provided material for monumental carvings, and different cultural areas produced related, yet wonderfully distinctive styles. The main groups are Haida, Tlingit, Tsimisian, Kwagiutl, Nuu-chah-nulth (or "Nootka") and Coast Salish. There are no precise dates for the origins of this carving—wood is so much more perishable than stone—but it seems highly likely that the skills and styles evolved over a period of several thousand years. Before European contact there were no metal tools, and carving with stone tools was a much more arduous process.

When the Europeans, hungry for animal pelts, began to arrive regularly in their ocean-going ships, the metals they brought with them for trade produced a revolution in the speed and finesse of the Native carvers. Native arts flourished for a while and evidenced a major blooming of work, but the trickle of Europeans soon grew to a steady stream. The diseases and alcohol which the Europeans brought with them began to decimate the Native population. A deadly tribal warfare, made more efficient by gunpowder, also took its toll. Soon, a bewildering new world order arose to deal another blow to the vanishing world of the potlatch and the totem pole. The fire was never completely snuffed out, but it sputtered many decades before the renaissance in Native art, which began in the late 1950's, brought back a strong Native presence in the cultural life of the Coast. Native carving now holds a prestigious place in the art galleries of the world, and many new totem poles have been created, but there has yet to be any real integration between contemporary architecture and the highly sophisticated decorative styles of these different Native groups.

The Musqueam and Squamish of the Coast Salish were the Native cultural groups present in what is now the Vancouver area. Present day Victoria was also under the Coast Salish influence. Historically they did not carve totem poles. Their house poles and mortuary posts were single figures, more realistically proportioned, and relatively free of the floating eyes and chevron shapes of the other Native groups. They were otherwise distinguished by carving in

the round more realistically modelled figures. Today monumental poles are being carved by all of the Native cultural groups. The first totem pole on the front garden of the Parliament Buildings is actually a Coast Salish pole carved by Cicero August. It should be followed by equally impressive poles from the other groups. The hard line stance taken by the Provincial Court over Native land claims may soon bring some other manifestations of the Native spirit to the Legislature as well.

Europeans, including Italians, English, Scottish, Spanish, Portuguese, Germans, Dutch, Greeks and Ukrainians, migrated to the West Coast and began to build the present day cities. Chinese labourers, imported to help build the railway, were the first Asian settlers to make a contribution, followed by Japanese, Korean, East Indian, and, more recently, Vietnamese immigrants.

While Victoria has retained a much more distinctly British air than cosmopolitan Vancouver, the British lion is the most prominent creature of ornament found on buildings in both cities. It seems ironic that the lion, the one indigenous creature neglected from the extensive bestiaries which decorated the totem poles, artifacts and lodges of the Natives, should be the symbol of the distant land which controlled the recent development of British Columbia.

In spite of Vancouver's size, Victoria has remained the administrative centre of the Province. Credit for at least a small part of this is due to the magnificent Parliament

Buildings, constructed between 1893 and 1898. The Provincial Legislature of British Columbia (its proper title) is a handsome building, which sits in a beautiful setting overlooking Victoria's harbour. It incorporates a wonderful harmony of domes, a grand Romanesque entrance, and an incredible store of imagery around it. The 14 full statues of figures from B.C. history, and the eight medallions depicting authors of the classics around the Legislative Library, are but a few of the sculptures decorating the Parliament Buildings. There are countless faces, foliage, and monsters (yes, there are vampires and all sorts of scary creatures peering out from the tops of the little window-pillars) which dot the structure.

The architect of this showpiece was new to the Pacific Northwest. Francis Mawson Rattenbury was born in Yorkshire, England in 1867. At the age of 25 he emigrated to British Columbia, a young architect with little experience, but a natural talent for self-promotion. The same Vancouver paper in which he first advertised his services, carried a call for entries to design a new and impressive group of legislative buildings in Victoria. He entered an ambitious design and succeeded in winning over dozens of individuals and architectural firms from across the continent.

Thus launched, he became one of the Province's most important and successful architects. It was an auspicious beginning, which led to many other important contracts including the Provincial Courthouse in Vancouver, and the Empress Hotel in Victoria. His career was filled with many other interests including such ambitious

undertakings as the design, construction, and sailing of a small fleet of steamboats to ferry people on their way to the Klondike, the creation of a proposed cross-Canada railway to Prince Rupert, with a shoreline hotel and sea/rail terminal, and similar projects on a grand, national scale. He saw himself as an empire builder, and if not all of his ventures were successful, his energy and enthusiasm were certainly boundless. Scandal led to his return to England in the 1930's, and he was murdered in 1935 by his second wife's chauffeur.

His B.C. Provincial Legislature buildings are a sophisticated mixture of styles. They show the prominent influence of the 19th century American architect Henry Hodgson Richardson, and architects of the Chicago School, such as John Wellborn Root. Richardson had an influence on many Canadian architects. The flamboyant interlaces of leaves, faces, and flowers originating with the Arts and Crafts movement in England, had blossomed into Art Nouveau across Europe and America. The influential American architects, beginning with Richardson, paralleled the Europeans in mixing revivals of older styles and exotic ornament together with up-to-date building techniques.

Rattenbury is invariably contrasted with the man who shared a few projects with him, and whose office was adjacent to his in Victoria's Five Sisters Block. Samuel Maclure had, like Rattenbury, done a lot of travelling, and had visited the Eastern United States. He specialized in fine homes for Victoria's emerging gentry, though one of his most lavishly decorated homes was for

the Vancouver sugar baron B. T. Rogers, on Davie Street, in Vancouver's West End. While Rattenbury was inclined to overlook details in his grand creations, Maclure was meticulous to the point of obsession in perfecting exterior and interior details. The Arts and Crafts/Art Nouveau ideal of a house, whose design is unified within and without, found a Canadian expression with Samuel Maclure.

His one commercial building in Victoria shows the influence of the decorative brilliance of another American architect, Louis Sullivan, who was one of the pioneers of the skyscraper. Sullivan evolved an entire philosophy around the ornament for a building, and designed Art Nouveau organic ornament to complement the non-organic crystaline forms of large structures. Maclure's Temple Building is a small architectural gem of terra cotta and brick, swirling with fantastic plant forms and eccentric faces peering out from them. While its stocky, yet well proportioned form is very different from the expansive glamour of Rattenbury's Legislative Buildings, the motifs of imaginative floral forms and peering faces are common to both. The influence of Sullivan's architecture on the Temple Building, and that of Richardson on Thomas Hooper and Rattenbury, clearly shows European trends and styles migrating west.

Thomas Hooper, another English born architect, had introduced Richardson's Romanesque revival to British Columbia in 1890 with the Metropolitan Methodist Church, and the Protestant Orphanage. He combined this style with an Art Nouveau interior in his 1904 Victoria Public Library. Paid for by American philanthropist Andrew Carnegie, it features many beautiful stone carvings—interlace patterns with snarling dragon heads, and flowing organic forms. There are also some faces grinning from the tops of window capitals, a Romanesque idiom also used by Rattenbury on his Parliament Buildings.

All of these buildings have common elements in the sinuous intertwinings of faces and floral elements, which were characteristic of the Arts and Crafts, or Art Nouveau style of the times. This style was brought to the West Coast through not only the influence of Henry Hobson Richardson and other American architects, but also via the printed page.

Decorated books were important to both the origins of the Arts and Crafts movement, and to its spread from England and France across Europe and, to a lesser degree, right around the world. Through the elaboration of Renaissance printer's ornaments, the swirling plant forms that characterized the style evolved, and the explosion of the printed media that followed the industrial revolution carried these ornaments far and wide. Rattenbury was one of many architects who were exposed to it in England. He and the other architects who gave Victoria and Vancouver the buildings which would shape them had, if their own creative design skills were not as evolved in the fanciful, access to books from England to provide them with ideas.

A surviving drawing of the Parliament Buildings suggest that Rattenbury himself produced the ideas for the many faces and figures that cover it, and an army of 50 stone carvers went to work on them. There are a lot of different faces peering down from the Romanesque window-pillars around the building. If one takes the time to look at them all, it becomes clear where the hand of a less talented or experienced stone carver has worked. Here and there are cruder, clumsier pieces in evidence, but most of the carving is superb.

Just above the grand Romanesque archway is a panel of Art Nouveau floral traceries. There is a lot of this kind of stone carving visible on Rattenbury's 1896 Bank of Montreal on Victoria's Government Street

as well. A parallel can be seen between the devilish face on the keystone of this bank, and the face on the keystone above the entrance to the Provincial Legislative Library. Rattenbury also designed the addition to the Parliament Buildings, constructed between 1912 and 1916, and in harmony with the rest of the Legislature, there is rich sculptural ornamentation both within and without this addition.

Rattenbury and Maclure shared the Five Sisters Block with several other architects of note. Thomas Hooper and his partner, Elwood Watkins, had offices there, and the designer of the building, Thomas Sorby, also had his practice in the same building. There were doubtless many exchanges of influence between these men. Housing several of the Province's most influential architects in one building eventually had an unfortunate side effect. The Five Sisters Block burned to the ground in 1910, and its contents were completely destroyed. Most of the drawings and records for many of the finest heritage buildings vanished in that fire, leaving many mysteries behind.

There are a number of buildings in the Gastown area of Vancouver which show the decorative influences of Richardson and the Arts and Crafts movement. The unknown architect of the Green Shields Building on Water Street could easily have been of one of the Five Sisters Block architects. It has some wonderful examples of intertwined floral motifs and human faces, and the Richardsonian influence is pronounced.

Vancouver architect William Blackmore also made use of Art Nouveau ornament on his Flack Block of 1899 at Hastings and Cambie Streets. It has the characteristic window pillars with plant forms carved in stone. A large and heavily ornamented entrance, with similar carvings to the Parliament Buildings, once graced this building. It has been replaced by a bland, insensitive shop-front modernization.

The architects of each of these buildings were in most cases responsible for the designs for their ornaments, and the work was then executed by stone carvers. In some cases however, sculptors were commissioned to create decorations for all, or part of the structure's ornamentation. A prominent sculptor named Charles Marega came from Genoa, Italy, to Vancouver in 1910, and worked on many public and private commissions in Vancouver and Victoria. He died in 1939, shortly after completing the massive lions at the southern entrance to the Lions Gate Bridge. His pupil, Vancouver sculptress Beatrice Lennie, contributed many fine works to the city, such as the monumental frieze at the front of the Labour Temple on West Broadway.

Ornamentation was once considered a necessary part of any work of architecture. It was important to revivals of various orders of Classical architecture, and to revivals of Romanesque and Gothic architecture. New styles had also emerged, such as Art Deco, synthesized from Mayan and Aztec architecture of Pre-Columbian Mexico and Central America, classical Egyptian styles, and the abstract streamlining trends of modern transportation.

A building from any time before the "International" could represent a style, a mixture of styles, or a reference to a quality the architect wished to evoke, be it heraldry, myths, or local legends. In the early years of this century new building materi-

als and techniques were pushing structures higher and higher, offering more and more surface to be decorated, up until what is known as the International Style all but banished any details other than rectangles of concrete, metal, and glass. Stone carving ceased to play any part in building construction. While there is no way in which we can go back to the golden age of masonry, it is important to realize that our quality of life is influenced by the walls that surround us, both inside and outside. Heritage awareness constitutes one side of this recognition, while the quality and design of

new structures is another equally important side. Some older buildings will sadly have to come down to make way for new ones, but the rate of growth in Vancouver has recently seen a drastic elevation of land values. When the demand for land outstrips availability, there is always a danger that irreplaceable heritage buildings will be pulled down for parking lots and condominiums. A balance between conservation of quality heritage buildings and sensitive renovations are the best that can be hoped for. Cities that grow with no sense of their roots, especially young cities like ours, risk loosing their cultural identity.

The Neo-Classical, Romanesque, and Gothic revivals seen here are no longer a force in contemporary architecture, but the more recent Art Deco Style showed a way one can point to the future, yet integrate the past. Post-Modernist architecture is clear evidence that the designers of the cold, hard, glass towers are reaching towards that missing element which we instinctively recognize in many heritage buildings. While still eschewing rich and fantastic decoration, the latest wave of skyscrapers makes oblique references to history: simple columns at the entrance, pseudo-mansard roofs and Art Deco profiles. The Post-Modernist aesthetic has also seen a freeing of the colour palette from the monotone grey, white and beige prescribed for the early glass towers. There is a break here from the purely crystalline geometry of the austere International style. Post-Modernism in Vancouver has taken a new step with Cathedral Place, a recent structure located on the site previously occupied by the Georgia Medical-

Dental Building, on West Georgia Street. In the face of considerable public opposition to the destruction of the Art Deco Medical-Dental Building, its architectural ornament became a link between the old and the new. Some of the finest terra cotta decorations of the Georgia Medical-Dental Building were carefully removed before its destruction, and fibreglass reproductions of them provide ornament for the new structure. While in this instance the lion and nurse motifs have become a part of a new building by way of heritage face-saving, the presence of sculpture in a fine contemporary building points the way to completely new sculptural creations which should be appearing on the architectural landscape. New materials, and innovative techniques developed by sculptors in the 50 year hiatus could make this a very exciting development.

Hidden Cities is a photo-survey of the major icons and decorative motifs displayed in these two Canadian cities. Many of these sculptures fall into more than one category, so subjects and styles are more pertinent to their discussion than a building-by-building review. There remain many details on buildings in both cities not accounted for here due to limitations of space, awaiting discovery by the inspired reader. At the back of the book are a series of maps of the important heritage areas of Vancouver and Victoria, with suggestions for walking tours.

Careful conservation, and a renaissance of meaningful ornamentation on new architecture, are equally important for growing cities like Vancouver and Victoria. The economics of demolishing priceless buildings for newer, larger structures must be

weighed against the cultural benefits to the city from renovation and preservation. A clear and consistent awareness of what makes a building of value will help people know what is theirs to rightfully enjoy as a part of the urban landscape.

Illustrations—

P. 9, Pan, entranceway to Gabriola, Davie Street, Vancouver

P. 10, Baroque ornament, Langley Street, Victoria

P. 11, Tsimisian carving, University of British Columbia, Vancouver

P. 12, Romanesque ornament, Parliament Buildings, Victoria

P. 13, Woman's face, doorway, Gabriola, Davie Street, Vancouver

P. 14, Detail, Labour Temple, West Broadway, Vancouver

Part One
Lions

While we have no big-game parks on the West Coast of Canada, we can nonetheless go lion-hunting in downtown Victoria or Vancouver. It may sound preposterous, but many of these creatures lie in wait for us, hiding on prominent city landmarks and buildings where we might never notice them.

Mountain lions are a part of the fauna of British Columbia, but they are never seen on totem poles or other works of the Native peoples. Like the mountain goat, which is only seen rarely, the cougar was seldom present on the ocean or river fishing grounds of the Native peoples of the West Coast.

Lions are, however, the totem beasts of the British Empire, and not surprisingly they began to appear in plenty with the spread of European settlement in the province. The lion, along with the Scottish unicorn, is one of the two supporters of the British Royal coat of arms, and was chosen as a symbol for the strength and supremacy of an Empire upon which the sun (itself connected symbolically with the lion) never set in the late 19th century.

The lion is called the king of beasts, a large, intelligent creature with a powerful body, massive teeth and razor-sharp claws. It fears no other animal and is known as a peerless hunter. Throughout Asia, Africa, and Europe, where it was once found, it was universally associated with courage and strength. It has been a natural choice for many rulers as a symbol of their dominion, having, in addition to its power and strength, a splendid appearance. Its head is circled and crowned by a long and magnificent mane, and its whole body is of a golden colour that shines like the sun.

Representations of lions ennobled the abodes of kings of many ancient civilizations. From Greece and Persia, to India and the African kingdom of Benin, the lion stood for the ruler of a kingdom. Even the enigmatic Egyptian Sphinx has a lion's body.

The nobility and fairness of the lion are also renowned—St. Jerome befriended a lion after removing a thorn from the suffering beast's foot, and the biblical Daniel, who was cast into a pit filled with lions, emerged from it unscathed.

Vancouver Art Gallery

There are two very large pairs of fully formed lions in Vancouver: one pair in front of the Art Gallery on the Robson Square complex, and the other at the southern end of the Lions Gate Bridge.

The pair in front of the Vancouver Art Gallery (previously the Provincial Courthouse), were created in 1910 by sculptor John Bruce at a cost of between $8000 and $10,000. Bruce and his assistant, Timothy Bass, carved them from granite quarried on Nelson Island. The carving was executed at the Vancouver workshop of stonecutters J.A. and C.H. McDonald, at 1571 Main Street. When completed, they were hauled by horse dray to the Courthouse and set in place with jacks, rollers, and manpower: quite a task, as they weigh several tons each.

The west lion was the target of serious vandalism on November 3, 1942. A dynamite blast shattered the back end of the beast, and shifted it several inches. The repair work was done by Herbert Ede and James Hurry, whose work was so precise that it is almost impossible to see the join.

The lion motif is continued around the

Vancouver Art Gallery

Vancouver Art Gallery

Vancouver Art Gallery

The lions by the southern entrance to the Lions Gate bridge were created by the sculptor Charles Marega. He had wished to make them from stone or bronze, but the budget would not allow it. Formed from cast concrete, and showing the Art Deco influence of the time, Marega's treatment gives them a timeless and monumental quality. The heads and bodies were cast separately, the concrete being poured in two large independent forms, to be joined later. They are enormous beasts, reclining with a solemn majesty, unmoved by the constant drone of traffic beside them.

Charles Marega was born in Genoa, Italy in 1876, received his training in Europe, and came to Vancouver in 1910 after working in South Africa. Some of the finest architectural sculpture in both Victoria and Vancouver came from Marega's studio at 822 Hornby Street.

Lions Gate Bridge, Vancouver

Art Gallery in numerous other sculptures, though only in the form of heads, which look down snarling from around the roofline of the building.

The Provincial Courthouse was designed by architect Francis Mawson Rattenbury to conjure up images of Imperial Rome. By the use of a monumental Neo-Classical Style, the strength implied by the ancient Roman judicial system is powerfully conveyed. That this was British law being put to effect however, is evidenced by the two massive lions—they are said to be exact copies of those in London's Trafalgar Square. The last case to be tried in this Courthouse took place in 1979.

Instrumental in the creation of the Vancouver School of Art, Marega was an instructor there for many years. Sadly, his death came in March, 1939, two months before the Lions Gate Bridge was officially declared open during a visit by King George VI.

Lions Gate Bridge

Sinclair Centre, Vancouver

Sinclair Centre, Vancouver

These two nearly identical pairs of lions are on the Granville Street side of the Sinclair Centre, at 739 West Hastings Street, known previously as the Post Office Extension. The architectural firm of McCarter and Nairne designed the building, and it went up between 1935 and 1939. The various animal and floral motifs on this building are all graceful designs well executed by master stone carvers. The McCarter and Nairne architects, J. Watson, C. Young and C.D Hunter, who worked on the decorations for the Marine Building and the Georgia Medical-Dental Building (seen elsewhere in this book), would have no doubt supplied the designs for them.

These superb relief carvings are not exactly at eye-level, and are best seen from the other side of Granville Street with a pair of binoculars. The stylized forms of these lions contrast well with the more naturalistic ones on the Royal Tower across the street. This was a government edifice, and the lion was chosen as a motif to display the connection with Britain, which was still very strong at that time. The building was opened by King George VI in 1939. After the Marine Building, this structure exhibits some of the finest Art Deco motifs in the City of Vancouver.

The stylish Rogers Building at 450-476 Granville Street features these marvelous glazed, cream terra cotta lion's heads. Take a look up from the intersection of Pender and Granville Streets to see them snarling down at the pedestrians. Then lean way back and look up at the roofline—in this case a projecting cornice, a common feature on Edwardian Commercial Style buildings. There are more lions looking down, 27 of them around the top of the terra cotta façade, making a total of 35 felines on the building. The architects were Gould and Champney, a Seattle firm, and the building dates from 1911-12. It was constructed for Johnathan Rogers, one of Vancouver's most successful developers, and twice the president of the City's Board of Trade.

The Rogers Building, Vancouver

Burrard Bridge, Vancouver

The Rogers Building

Vancouver's Burrard Bridge, which was completed in 1932, also has a pride of lions to adorn it, albeit only their heads. Many hundreds of people drive under their watchful eyes every day of the year. These 16 felines are another creation of sculptor Charles Marega, who designed and executed all the decorative motifs for the Bridge.

Burrard Bridge, Vancouver

21

Above the entrance to the Carnegie Centre, at 401 Main Street, is this grave, yet handsome feline. He is among the least stylized of all the lions in the city. Though somewhat at the mercy of the local pigeons, he remains in excellent shape, having gone up with the building in 1902-3. The building was designed by G.W. Grant as the main library for the City of Vancouver, a function it served from 1903 to 1957. Built with funds donated to the city by the American philanthropist Andrew Carnegie, it was renovated and enlarged in the early 1980's, and is now an East-end cultural centre. It is a blend of Neo-Classical and Romanesque Styles, and inside it has a spiral staircase which winds up along an eccentric curve past three glowing stained-glass windows depicting three famous men of letters, Sir Walter Scott, Robbie Burns, and William Shakespeare.

Industrialist Andrew Carnegie (1835-1919) made his fortune in the steel business. Though not a socialist, he believed that the accumulation of huge sums of money as an end in itself was both selfish and evil.

In 1901 he sold his company to another millionaire, J.P. Morgan, and began to donate his fortune to universities, colleges, churches, trusts and many other causes. He felt that a man who died rich was a disgrace, a radical idea at the time, and quite unheard of today. These altruistic ideas developed while he was still a young man. He felt that wealth should be distributed in such a manner as to best benefit the largest number of people, which he regarded as "scientific philanthropy."

The money he donated to cities for library construction was his most visible legacy. In the eighteen years from the sale of his business, until his death in 1919, he would give away $350,000,000—to this day a staggering sum of money. Of this sum $62,000,000 was distributed to the countries of the British Commonwealth, a portion of which paid for libraries in both Vancouver and Victoria, each city receiving a grant of $50,000.

Carnegie Centre, Vancouver

On the west side of the Pemberton Building, guarding the entrance at 744 West Hastings Street, are two big terra cotta cats. Living deep in the concrete jungle, these fellows almost never see the sun. This building dates to 1911, and was built by William Bauer, from whom its original name, The Bauer Building, was derived. This is an excellent example of the Edwardian Commercial Style—early commercial buildings of at least five floors, characterized by Classical touches and terra cotta or glazed brick facings. It was designed by W. M. Somervell, one of the team of architects who designed many of the buildings, most notably the banks, in the Vancouver area.

Pemberton Building, Vancouver

The Hotel Vancouver at 900 West Georgia Street displays a staggering amount of carved ornamentation. This is a building on a grand scale, and the decorative elements mirror this impression. It is the third Hotel Vancouver in the city. The first was completed in 1888, just after the Canadian Pacific Railway had joined up its transcontinental railway line at Craigellachie, connecting British Columbia with the rest of Canada. It was expanded in 1901 with a Chateau-style wing by the ubiquitous F.M. Rattenbury, then the principal architect for Canadian Pacific. He designed many of these hotels with steeply pitched Chateau-style roofs for the C.P.R. across the country. There is a strong connection between his work and the current Hotel Vancouver designed by Archibald and Schofield.

Hotel Vancouver

The second Hotel Vancouver (previously situated where the Eatons Department Store is now) was a beautiful structure, built after the manner of an Italian villa, with enormous rooms and a sumptuous roof garden. It was used during the second world war to billet soldiers, but after the war there appeared to be no market for the luxury it offered. In spite of public opposition, it was demolished in 1949. Nothing like it remains anywhere in British Columbia.

While the current version is also in the Chateau-style, at its conception it was exclusively a C.N.R. hotel. The Gothic Chateau had in the intervening years become a Canadian architectural idiom. This new C.N.R. building was to be called the "British Columbian Hotel" and later the "Canadian National." Construction was begun in 1928, but it was prolonged because of the Depression, work coming to a halt in 1931, as the C.N.R. faced financial difficulties. Its completion was finally made possible by a deal made between the C.P.R. and the C.N.R. which amalgamated them as managers and brought the title of Hotel Vancouver to the C.N.R. structure for the first time.

It was completed in 1939 to coincide with the Royal visit, when it was opened by King George VI. During these eleven years, the first architect, John S. Archibald, died, and the architectural work was completed by John Schofield of Montreal. It is almost identical in form to the Royal York Hotel in downtown Toronto.

Among the many creatures adorning it are these dissimilar lions above and around the main entrance on West Georgia Street. The lions are marks of splendour, fitting emblems for the entrance of the city's premier hotel, and providing a contrast with the gargoyles above who ward off evil (in these days, as in the days of the building's construction, the terrifying spectre of economic depression).

Hotel Vancouver

Banks were once built as great Greco-Roman temples of commerce, and often adorned with the king of beasts. In Vancouver there are several of these links to the Greco-Roman heritage, albeit with some interesting variations. Take a look at this strange plant with a lion's head sprouting out of the middle of it. There are quite a few of them up around the sides of the building.

Currently a Bank of Montreal at 500 Granville Street on the corner of Pender, this finely detailed structure was originally a Merchants Bank, constructed in 1916. The Montreal-based Merchants Bank was absorbed by the Bank of Montreal in 1921. The architects were Somervell and Putnam. It was the second Merchants bank in the city, erected only three years after the first, at Carrall and Hastings, a manifestation of the shift of the banking district away from upper Main Street and over toward the West End.

At the corner of Douglas and Yates Streets in Victoria is a grand Bank of Montreal adorned with some regal felines. These have a similar look to some of the lion heads which look down from the former Vancouver Courthouse, (now the Art Gallery); and not surprisingly the architect here was also F.M. Rattenbury. Built in 1907, this Beaux-Arts building was originally the Merchants Bank of Victoria. It was built at considerable expense and promoted as the city's most fireproof bank. The main structure is built completely of reinforced concrete, and the stone facing is of ashlar granite.

Bank of Montreal, Victoria

Bank of Montreal, Vancouver

Union Bank, Vancouver

A fine winged pair of lions have roosted up above the main entrance of this Second Renaissance temple bank at 560-580 West Hastings Street. Built 1919-1920 as The Union Bank, it was a Toronto Dominion Bank until the late 80's. The architects were again Somervell and Putnam, having made something of a specialty of temple banks. No skeletons of winged lions have ever been found, but these creatures occur in human artifacts dating back nearly 5000 years, to the origins of urban society in the Middle East. They are also the symbol of St. Mark the Apostle.

On Yates Street in Victoria stands a Birks jewelry store with the British Royal crest above the main entrance. The lion and the unicorn have been the Royal symbols since the reign of King James I who, as a Scotsman, installed the Scottish unicorn on the right side of the crest, replacing the eagles, dragons, greyhounds and swans which had preceded it. Subsequent British rulers placed the lion on the right.

Birks Jewellers, Victoria

A different crest with the same British Royal lion and unicorn motif are to be found on a very large image on the Central Post Office on West Georgia Street in Vancouver. Though no longer a residence of the Royal Mail, the crest does a great deal to enliven the huge brutalist façade of this very functional giant which occupies an entire city block. Built from 1953 to 1958, when ornamentation had become unfashionable in the wake of the International Style, the architects McCarter and Nairne were fighting to keep alive here a ghost of the decorative

glory of their earlier buildings.

Central Post Office, Vancouver

Perhaps one of the most beautiful Police Stations in Canada can be found at 625 Fisgard Street in downtown Victoria. This fine Classical Renaissance building was built in 1920. The architect was J.C. Malcolm Keith. A wild looking lion blazes from the keystone above the main entrance.

At 1010 Langley Street in Victoria, this otherwise plain three-storey building is enlivened by two of these regal beasts, and some other more ornate decoration. Designed by H. S. Griffiths for the printing

Police Station, Victoria

firm of Sweeney and McConnell, it dates back to 1910. The facade of the building is glazed brick, and the lions are of terra cotta.

Langley Street, Victoria

The matching set of lions up on either side of 440 West Pender Street, a rather nondescript two storey brick commercial building, have a large shape passing through their mouths, suggesting that their creator may have used a doorknocker as a model. These heads were mass produced, rather than being specifically created for the building, and the African lion was, as usual, the model.

440 West Pender Street, Vancouver

Another lion with a doorknocker look is in evidence at the corner of Cambie and West Pender streets. Actually, there are quite a number of these beasts up around the middle of the building. Originally known as the Edgett Building, it was built about a year after the Province Building

(1909), with which it shares a certain stylistic continuity. Both buildings are attributed to architect A.A. Cox. They were connected by an archway over the alley in 1924, the year after the Province was purchase by the Southam family.

181 West Pender Street, Vancouver

Time and heavy coats of paint have blurred the features of this cast metal capital, but the lion is still there. The idea of using precast metal elements looked forward to building techniques of the coming century, but the capital seen here is carrying on the forms of the traditions of plaster and stone. Currently a Goodwill store at 560 Yates Street in Victoria, this building dates back to 1863, and was for years the home of W. Jeffrey, Clothier.

560 Yates Street, Victoria

In this latter part of the 20th century we are beginning to lament the loss of many architecturally unique buildings in the city. The Georgia Medical-Dental Building was Vancouver's first Art Deco skyscraper, designed by McCarter and Nairne, and constructed between 1928 and 1929. This handsome, and extensively decorated tower was demolished to make way for a new office building.

The new structure, Cathedral Place, has some of the stepped-back, Art Deco lines of the previous building, and also attempts to make reference to the Hotel Vancouver, located across the street from it, with a steep green roof. Unfortunately the latter is not a great success, as it looks like something just tacked on top, in direct contrast to the graceful way the sleek lines of the Hotel Vancouver's copper Chateau-style roof grow out of the mountain of clayburn brick and Haddington Island stone that make up its exterior.

Although the new glass tower blends in well with the other recent behemoths around it, the delightful brown brick and terra cotta icing which covered the exterior of its predecessor, and complemented the warm brown exterior of the neighbouring Hotel Georgia, will be missed for some time.

The shield-bearing lion, seen here on both the original Georgia Medical-Dental Building, and duplicated on Cathedral Place, has little relationship to the healing arts. The lion was purely a reference to the British Empire. There was considerable civic opposition to the demolition of the Georgia Medical-Dental Building, but, these excel-

lent reproductions of the beautiful decorative elements of the old building help to preserve its memory. The street-level placement of these lions makes it possible to appreciate them even from a low-slung sports car.

Georgia Medical-Dental Building

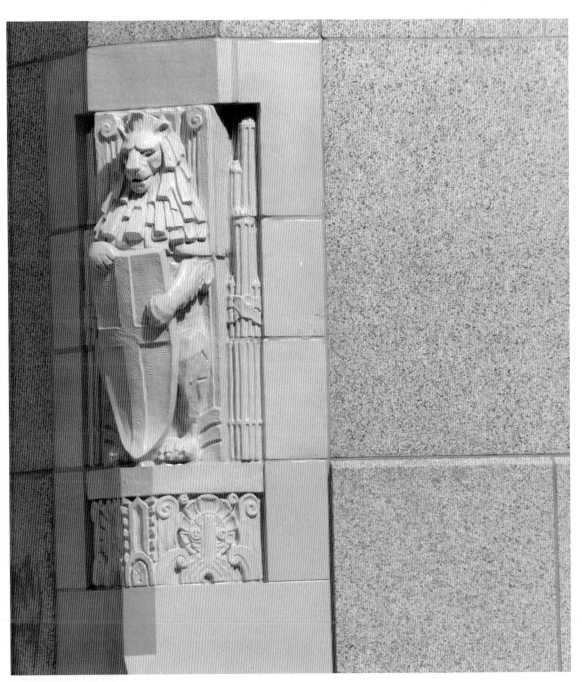

Cathedral Place, Vancouver

Hidden Cities

At the corner of Hastings and Granville streets in Vancouver is the Royal Bank Tower, the first really tall bank tower in the city, rising to 250 feet. Dating from 1931, it was designed by S. G. Davenport along the lines of the Bank's Montreal head office. Only half of the intended structure was built, the eastern half going the way of many planned expansions in the wake of the great Depression of the 1930's.

The building is an eclectic mixture of styles, the top showing the influence of New York and other American cities, which crowned their skyscrapers with Neo-Gothic touches, and a few Art Deco details around some of the windows. The main influence on this stone-clad tower is, however, the Romanesque. The Neo-Romanesque Style had vanished from the scene twenty years earlier in both Vancouver and Victoria, but just as the Greco-Roman temple style persisted, thanks to the conservative nature of banks, so too the Romanesque still flourished here. Both the exterior and interior stone carvings were inspired by the Romanesque churches of southern France. An interesting variant on the temple theme

Royal Bank Tower, Vancouver

Royal Bank Tower

for banks, it has retained most of its splendour inside. Haddington Island stone above a base of Nelson Island granite is the material used for the three main façades, with the exterior stonework carrying on into the main banking hall. Some of the finest stone carving in the city is to be found around the archway of the main entrance, and in the allegorical scenes featuring various felines and other creatures around the Granville Street side of the building. The lion conquering the serpent is the triumph of the just over their enemies. This is one of the first instances in Vancouver of the use by the Royal Bank of the lion as an emblem, which was later to be stylized and used as their trademark. Again, the chief enemy in this case was economic depression, though the serpent seems a strange symbol for a cashflow problem. The griffin is a fantastic creature, composed of the body of a lion and the wings and head of an eagle. This combination of two powerful creatures was regarded as a symbol of watchfulness, particularly that of a guardian of treasure, precisely the kind of beast a bank should employ to look after the loot.

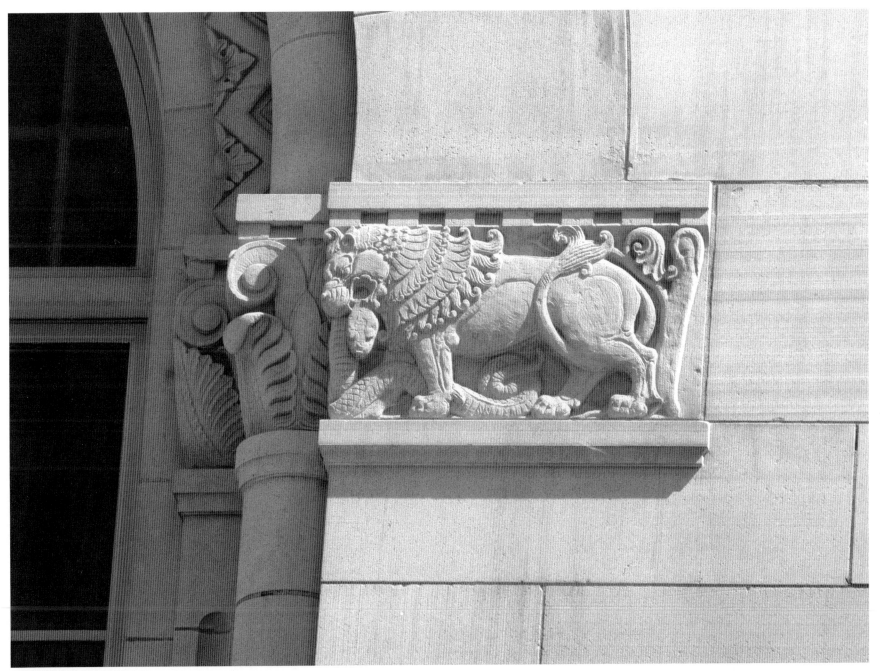

Royal Bank Tower, Vancouver

Hidden Cities

Part Two
Dragons & the Orient

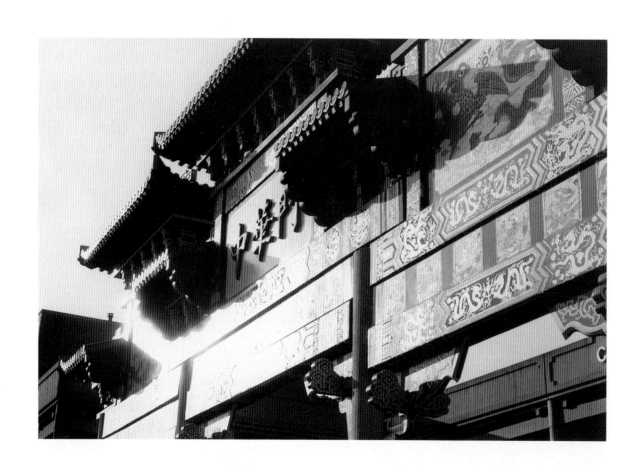

The dragon is a mythical creature whose origins are shrouded in mystery. There exist countless visual interpretations of this powerful creature throughout the world. They usually show a large reptile which may have a pair of leathery wings, two or four legs, and flames or smoke billowing from its mouth and nostrils. The dragon has been portrayed across Eurasia, from Wales and Ireland to China and Japan, though its symbolism changes as we move from West to East.

In Europe, though used occasionally as an emblem of power in heraldry (a red dragon is the heraldic symbol of Wales), it is portrayed as a symbol of evil, associated with the biblical serpent, and Satan. The legend of St. George and the dragon is a theme explored by a number of European painters and sculptors. The tale of the knight battling and destroying the scaly monster and rescuing the princess is a symbol of the triumph of good over evil, and a host of other Freudian/Jungian interpretations.

The Asian dragon is regarded as a deity

with control over water. In contrast with the negative place it holds in European representation, it has always been revered in the Orient: for its life giving properties through oceans, rivers, clouds and rain, and feared for its terrifying side. Thunder, lightning, typhoons and tidal waves are the dark side of the dragon's power, but these too are part of the natural order. The dragon is at least as old as Chinese history.

Tales and graphic representations of dragons date back thousands of years and form part of the grand cosmology evolved by Chinese sages, and passed on to the beginnings of Japanese and Korean civilizations. As a symbol of fertility and the vital energy of life it became the symbol chosen for the Imperial emblem, with the image of a five-clawed dragon reserved for the Emperor and princes of the first and second ranks. While we tend not to associate dragons with North American Native peoples, the two headed reptile known as the Sisutl is very close in appearance to the Eurasian depictions of the mythical dragon.

While the dragons seen on these pages are both European and Oriental, the large Asian populations in both cities have provided some of the more exotic and beautiful examples of these creatures, as well as other ornamental features: carved and painted gateways, ornate pavilions, and carved guardian creatures can be found.

Vancouver's Chinese community has created a full-scale Classical Garden in the Dr. Sun Yat Sen Park at 578 Carrall Street, just behind the Chinese Cultural Centre. This traditional Chinese garden evolved from the private gardens of scholars and administrators of the Ming Dynasty, during the 13th to 16th centuries. In addition to bizarre, wind-blown rocks shipped to B.C. from China, the garden contains ornate wooden pavilions, and a large artificial pond. The tall white wall which surrounds the gardens has windows with traditional lattice patterns in them. These carved and polished geometric lattices have been incorporated into Chinese architecture for over 3000 years. The Dr. Sun Yat Sen Gardens was constructed from 1984 to 1986, opening then to coincide with the City of Vancouver's centennial.

Dr. Sun Yat Sen Gardens, Vancouver

The largest part of the park is open free to the public through most of the week. Sitting amongst the strange, naturally sculpted rocks, gazing at an ornate classical wooden Chinese pagoda transports one to another world thousands of years and miles

Gate of Harmonious Interest, Victoria

from the drone of traffic a few blocks away on the Georgia viaduct.

Work began on the Chinese Cultural Centre in 1980, and thus far three stages have been completed: the Administration and Commercial wings, and the Auditorium and multi-purpose building. A museum and Library have yet to be built. There are many painted dragons on the large, colourful gate that stands in front of the Centre. Originally part of the China Pavilion at Expo 86, the gate was later donated to the City of Vancouver, which in turn donated it to the Chinese Cultural Centre.

Downtown Victoria, like Vancouver, has a "Chinatown" which features a traditional gate covered with carved and brightly painted ornamentation. Flying dragons are the most prominent motifs, with Lion Dogs standing sentry at either side. Known as "The Gate of Harmonious Interest", both it and the Lion Dogs were donated to Victoria by its sister city in China, Suzhou, in 1981.

A favorite place for dimsum, a Chinese brunch, is Ming's, on East Pender by Main. On the outside of the building are dozens of these tiny little dragons, the motif losing its power, though not its fascination, in being reduced to a repeating decorative element. Paintings, painted reliefs, ceramics and contemporary signs by restaurants make the dragon the most frequently seen imaginary creature in both cities.

Ming's Restaurant, Vancouver

Gate, Chinese Cultural Centre, Vancouver

Detail, Chinese Gate, Vancouver

Detail, Chinese Gate, Vancouver

Detail, Chinese Gate, Victoria

Detail, Chinese Gate, Victoria

Lion dogs, acting as guardians, are to be found beside gates and doorways. Just like gargoyles in Western architecture, and fetishes in Africa, these terrifying carved stone beasts are placed by an entrance to frighten off evil and discourage it from entering. Both the Chinese gate on Fisgard Street in Victoria, and the gate on Pender Street in Vancouver are guarded by fierce stone lion dogs on either side of each gate. Known as the Dog (or Lion) of Fu, it was originally a Buddhist temple guardian. The lion is not a native of China, and though it was no doubt imported by traders into the country, its mythological status has been mixed with

Lion dog, Vancouver

Restaurant, Vancouver

design, an ancient mythological symbol given new life as a popular icon.

that of the dog. The dog is more figuratively a guardian creature than a lion, but China is the home of several dogs with a lion-like appearance. The Chow and the Pekinese both have manes of long collar hair, and the Pekinese is also a golden colour. Some carved lion dogs are more canine, while others are more feline. They usually have a carved stone ball suspended behind their teeth which one can roll freely back and forth — for good luck.

Another smaller pair of fine golden dragons are up on Hastings Street, above the entrance to a former Chinese restaurant, across from Woodward's department store. These are mass-produced metal artifacts, yet they come from a fine dragon

Lion dog, Victoria

Royal Tower, Vancouver

A peculiar dragon with a dog-like face and the coiled tail of a sea creature sits at the bottom of the archway that crowns the entrance to the Royal Tower on West Hastings Street at the intersection of Granville Street. There are many creatures and swirling motifs carved in granite here.

Dragons are also a part of the fantastic bestiary that clings to all four sides of the Hotel Vancouver. Two pairs of them are visible above a street level window, breathing flames towards the pedestrians who hustle up and down Hornby Street. One of these can be seen in the introduction.

Most of the Hotel's dragons are found on the north side of the building. This winged pair guarding a brazier are near the corner of Georgia and Burrard. Other dragons may be seen quite high up the grey brick and granite facade where they lurk beside windows. You have to crane your neck back and use some powerful magnification to see them. Occupying half a city block, and stretching 365 feet up into the sky makes the Hotel Vancouver a substantial surface to cover with carvings.

The many large granite sculptures around the building were executed by predominantly European stone carvers who travelled the country in search of work. The dragon, as a universal myth, makes an appropriate creature to embellish a hotel catering to visitors from around the world.

Both Europe and Asia have long traditions of dragons in their cultures, and it is fascinating to see how the two kinds have spawned on a far shore. The dragon has found a place as a symbol of evil in the 20th century in motion pictures such as: "The Seventh Voyage of Sinbad," "Willow," "Dragonslayer," and "The Wonderful World of the Brothers Grimm."

In Victoria there are a pair of strikingly original European dragons in front of what was once the Victoria Public Library. Located at 794 Yates Street, it was built in 1903. This library was also built with funds donated by the American philanthropist Andrew Carnegie. The building is now a credit union. Though the Art Nouveau decor of the original interior has disappeared, the Neo-Romanesque facade and the dragons are intact.

They are carved in stone relief after a manner which recalls the interlace carvings of the Vikings, and the intricate painted knotwork of Celtic manuscripts similar to that found in the Book of Kells, and the Lindisfarne Gospels. This style was one of the inspirations of the Arts and Crafts movement which led to Art Nouveau. Certainly the literary connections to the old Gospels, and the decorative style of books connected with the Arts and Crafts movement explain the presence of these beasts on a library. It was designed by Hooper and Watkins in a pure Richardsonian Romanesque style. The massive arched entrance which these dragons frame, as well as the rough-hewn stone and Classical portico, are all associated with the style. There are a number of other interesting examples of stonecarving on the front of the building.

Hotel Vancouver

Carnegie Library, Victoria

Yuen Fong Store, Vancouver

Hidden Cities

A beautiful polychrome relief in the traditional manner can be seen up above the Yuen Fong store, at 242 East Pender Street. It depicts a wild, swirling dragon and a phoenix bird, both in polychrome relief, against a background of stylized clouds. Like the dragon, the phoenix is also a symbol known to both the East and the West. In the Western myth of the phoenix the mythical bird is said to live for 500 years, and then burns itself to ashes on an altar. Emerging from this pile of ashes, it is reborn as a young bird. The Phoenix is a symbol of regeneration, and complements the life-giving powers of the dragon.

In China the Phoenix was traditionally a symbol of the Empress. The pairing of these two creatures, the dragon and the phoenix, is a Chinese symbol of the balance of female and male principles: the Yin and the Yang. These two symbolic creatures facing off in the clouds makes for a powerful subject which has been given a strong treatment by the artist.

In addition, at street level, and just outside the store, we find a pole with a brightly-coloured, carved wooden dragon coiled around it. It has been encased in plastic to protect it, as this is an extremely busy footpath.

At 281 East Pender Street in central Vancouver, above Super Fresh Foods, there are a pair of bright and powerful flying dragons created in polychrome relief. The abstract clouds it flies through give a sense of the scale that a dragon should be viewed from, an enormous and awesome beast, an appropriate symbol for the primal powers of nature.

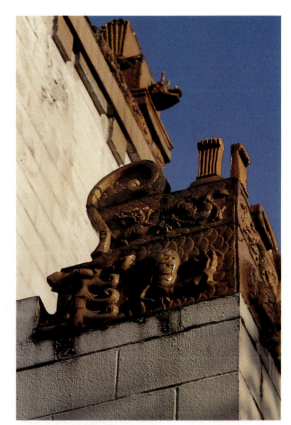

Bank of Montreal, Vancouver

A branch of the Bank of Montreal located at 178 East Pender Street was designed to harmonize with the buildings of Vancouver's Chinese district. It is a creative and successful attempt to blend the elements of classical Chinese architecture with the streamlined futuristic lines so common today. Designed by Birmingham and Wood, and constructed in 1971, it is one of the first major buildings in Vancouver to feature decorative motifs since the fertile Art Deco period of the 1930's. At the roof corners there are several superbly executed terra cotta dragons with a rich golden glaze.

Super Fresh Foods Store, Vancouver

Hidden Cities

Part Three

An Architectural Zoo

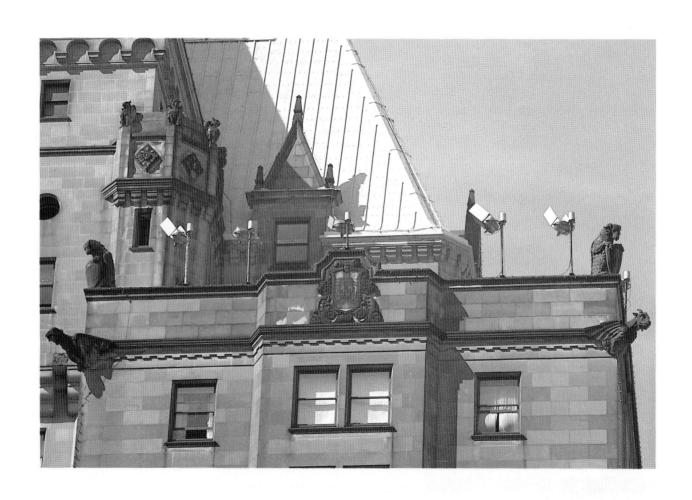

Just as our modern cities have few species of animals in them, our new buildings are enlivened by few representations derived from natural fauna.

The original West Coast sculptors covered their artifacts and architecture with beautiful carvings of their symbols, creating an impressive bestiary, most notably on the totem poles associated with their architecture. Despite the fact that many of these carvings have been lost to the elements and foreign collectors, a revival of this art form in recent years has allowed these creatures to return to our cities.

The many colonists who came to the Pacific Northwest from all over the world in the last two centuries brought with them their own equally impressive bestiary with which they adorned their new structures. Just as the modern city tends to limit the available flora, so too the fauna is restricted to a few hardy or domesticated varieties. Public sculpture and architectural ornament offer an alternative to this significant absence. As we have already seen, there are many lions and dragons in both cities. There is also a variety of other creatures to be found in the *hidden cities* of

Vancouver and Victoria. Eagles, beavers, fish and flying horses are among the many interesting real and imaginary animals from all corners of the globe represented in the architectural zoos of these two cities.

On the grounds of the University of British Columbia in Vancouver are a number of fine totem poles representing most of the major Native styles, most abundantly that of the Haida, distinguished by a monumental head to body ratio, usually close to 1:1. They were carved in the early 60's by a group of Native carvers (among them Bill Reid) who were attempting to revive the Native traditions, which had waned through most of the century. The grace and power of these monumental carvings gives testimony to their success. They are situ-

U.B.C. Museum of Anthopology

U.B.C. Museum of Anthopology, Vancouver

ated on a spectacular clifftop setting, overlooking Burrard Inlet and the Coast Mountains, along with two Haida post and beam structures. Behind them sits the U.B.C. Anthropology Museum, which contains many more Native carvings inside, in addition to cultural artifacts from around the world. This museum was designed by Arthur Erickson after the monumental post and beam style of Native architecture.

A fine carving from a Tsimisian pole, created by Walter and Richard Harris, features a big frog with a smaller frog in its throat. The hiding of faces and parts of faces

within a design is one of the most prominent aspects of the art of Northwest Coast Natives. Elsewhere on the same pole are human figures, a killer whale, a wolf, and a mosquito.

There is in the finest work a precise balance between the playful visual exercise of fitting a mixture of abstract and figurative elements together in a satisfying composition, and a respect for the mythological creatures and stories and the traditions, whereby they are portrayed and juxtaposed.

The totem poles at the UBC Anthropology Museum are about 30 years old, and

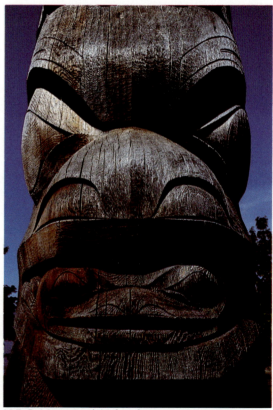

U.B.C. Museum of Anthopology

impress us both by their size, and the power of their imagery. Native artists continue to carve and sculpt in both traditional and contemporary methods.

On the plaza in front of the Vancouver studios of the Canadian Broadcasting Corporation at the corner of Hamilton and West Georgia Streets is a polychrome Kwagiutl totem pole which was carved by Richard Hunt. Hidden from view from the street by trees, the pole displays a mighty winged bird and a bear holding a woman to its chest. Though somewhat dwarfed by the huge, industrial C.B.C. structure be-

C.B.C. Building Plaza, Vancouver

hind it, the bright colours and lively forms add a much-needed human touch. This mid 1970's edifice was designed by the firm Thompson, Berwick, Pratt, and Partners.

The Native Education Centre, at 285 East 5th Avenue, in Vancouver is based on the robust architectural designs of the Native Peoples of the Pacific Northwest.

This wonderful building features a superb totem pole with a ceremonial entrance at its base. Carved by Tsimisian carver Norman Tait and members of his family, it tells a story with creatures of land, sea, and air, and human figures flowing into one another. The beautifully carved little bear cub is particularly delightful.

Native Education Centre, Vancouver

Native Education Centre, Vancouver

Native Education Centre

41

Harding Memorial, Vancouver

This powerful bronze eagle was created by sculptor Charles Marega as a part of the Harding Memorial in Stanley Park, commemorating the visit of the American President Warren Harding to British Columbia. This bird of prey was chosen as America's national animal as a symbol of freedom. Eagles certainly have the freedom of the skies — capable of soaring down out of the skies from hundreds of feet to land precisely on moving victims in the air, on land, and even under the water.

Another eagle, which sits with its wings spread out, at the edge of a circular pool, is located in front of the Library building added by F.M. Rattenbury to the B.C. Provincial Legislative Buildings in Victoria. Though not modelled as precisely and powerfully as Marega's, this eagle is still a realistic bronze representation. It is a fish-eagle, and it sits with its claws on a big salmon, freshly caught. These two creatures form parts of a bronze sculpture which includes a plaque bearing a capsule history of Vancouver Island from the time of Captain Cook, to the time of union with British Columbia in 1866.

B.C. Electric Showrooms, Vancouver

Parliament Buildings, Victoria

Here is an image perfectly suited to the original purpose of the former B.C. Electric Showrooms: a graceful peacock spreads its wings from inside a wreath. Created from a sheet of bronze, this showy bird is to be seen on Dunsmuir Street where it meets Granville. The bronze relief here is somewhat shallow, although extremely well executed. Unfortunately, where it is situated on the large façade of the showrooms, it is too small and indistinct to be easily appreciated from the street.

Two kissing fish are visible from the walkway which runs along the Granville side of the Sinclair Centre around to The Station. They are made of cast concrete, and the motif occurs several times here. Though set a little low, they are easily seen from the walkway. The style is Art Deco, but the fish look like they could have come almost unchanged from a 2000-year-old Roman mosaic, with their twisted open mouths and somewhat human eyes. This building was constructed as an extension to the former Chief Post Office. The architects were McCarter and Nairne, and no doubt the same designers who worked for the company on the Georgia Medical-Dental Building and the Marine Building created some of the Art Deco ornament seen here.

Sinclair Centre, Vancouver

A pair of, pouting fish can be seen up the side of the Royal Theatre in Victoria. This terra cotta ornament owes much to classical models, or the spouting fish that one sees in the margins of old sailing maps.

Royal Theatre, Victoria

Canada's national animal is a large rodent. The beaver is highly regarded for its industry. Nature's most accomplished architect, the beaver is famous for building dams, behind which are to be found its split-level mud lodges as dwelling spaces.

Crowning the roof at the front of a building currently known as Century House, at 432 Richards Street in central Vancouver, are a pair of beasts known occasionally as the "flying beavers." This is a misnomer, as the shapes on their backs are actually shells. The building was designed for the Canada Permanent Mortgage Corporation by J.S. Taylor, and completed in 1912, following a classical model. Apart from the beavers, there is little ornamentation on the façade.

Century House, Vancouver

This stylized Pegasus, the mythical Greek flying horse, soars up at the front of Vancouver's Greyhound and Pacific Coach Lines Station, at 150 Dunsmuir Street. Originally built for B. C. Motor Transport Ltd. in 1946, the building is a slight example of Art Deco. Pegasus was said to have sprung fully formed from the head of the Gorgon when she was slain by the hero Perseus.

Greyhound Station, Vancouver

Hidden Cities

On the western side of the Hotel Vancouver two pairs of turkeys, complete with ears of corn, watch the traffic on busy Burrard Street. The turkey is a distinctly North American bird, while corn is a Native American contribution to the basic foods of the world. Both are associated with the North American feast of Thanksgiving.

Hotel Vancouver

The Hotel Vancouver is a storehouse of animal imagery. In addition to lions and horses there are several ram's heads and complete rams looking down with the gargoyles above. The carvings on the Hotel Vancouver are largely taken from models found in medieval French churches. These animal gargoyles, which include a bear, a wolf, and the ram (the winged horse is perhaps an exception) are all creatures associated with mountains and forests, in addition to having long symbolic relations with history and mythology. The ram features in the Bible, as well as in the ancient practice of astrology, where it is the first sign of the zodiac. Elsewhere, an aquiline gargoyle gazes down on the city, contem-

Hotel Vancouver

plating flight. The Hotel Vancouver was one of the last buildings in B.C. ornamented with a wealth of stone carving. The carvings took a dozen or so men a year to complete, some of the granite blocks weigh over a ton.

Hotel Vancouver

A lovely pair of seahorses float a couple of floors up the north face of the Hotel Vancouver. The artist has made no attempt at creating real seahorses, but has followed his imagination and freely grafted horseheads to fan-

Hotel Vancouver

ciful fishtails. The designer has fitted these creatures neatly beneath a window-sized rectangle — the resulting carving is a real delight, and fills the tight squares with movement.

Around the main entrance to the Hotel Vancouver, on West Georgia Street, are several pairs of winged horse heads, emerg-

Hotel Vancouver

ing from sculpted foliage.

Hotel Vancouver

Located on Victoria's Government Street, the Canada Customs Building has its mundane, grey exterior enlivened with a Royal British crest in full colour featuring this handsome unicorn.

Post Office, Victoria

This strange, but colourful, ceramic fish sits up on top of the Mandarin Centre at 627 Main Street, in the heart of Vancouver's busy Chinatown. The Mandarin Centre was built in 1972 for Vancouver developers Dean and Faye Leung.

Mandarin Centre, Vancouver

Above the corner entrance to the Dominion Building, another beaver gazes down on the street. It sits on top of a shield which widens at the bottom to accommodate a blazing B.C. sun setting into the Pacific Ocean. Like the two cherubs below it at street level, the beaver is made of glazed terra cotta.

Dominion Building, Vancouver

Part Four

Hidden Faces & the Romanesque

The use of the face as a design element is universal—the eyes, ears, nose and mouth, and the ovoid outline, are present in some combination throughout all of the world's civilizations. Wherever human beings have created art of any kind, the face has been used as a motif.

The ancient practice of placing the heads of enemies on walls, and the carving of fetishes and gargoyles to ward off evil, were some of the human practices which associated the head with architecture. The human body is as infinitely varied as the face, but when we seek to identify another person, it

is always the face which we look to for recognition. Windows may be perceived as eyes, and doors as mouths.

It is so easy to overlook the many intriguing, carved representations of faces that look down from the older buildings in the city. Both Victoria and Vancouver have many buildings with faces hidden on them: angelic cherubs, beaming youths, grimacing gargoyles, and stern old men, are among the different representations we may find.

Romanesque architecture brought back the face in stone carving in Europe's Middle Ages. It arose during the troubled era of war, plague, famine and feudalism. The churches of the time were built of heavy stone, to be used for defence as well as holy ceremonies. A rebirth of the sculptural side of masonry took place in the 11th century. While the subject-matter might treat specific themes from the Bible, the stories chosen represented most often the basic Christian themes of redemption versus damnation. Angels, devils, and demons were motifs that captured the popular imagination of the time, and depictions of the horrors of Hell performed the dual function of showing the consequences of evil, and providing a visualization of the unseen terrors of the time.

By carving the fear, shame, and anguish into demons, monsters and grinning devils, then offering the glowing contrast of depictions of Heaven,

Jesus, Angels, and the Saints to the congregation, the nightmare world of the dark ages was made a bit more tolerable.

Neo-Romanesque and Neo-Gothic architecture grew from the same roots that later produced Art Nouveau. The carvings of interlaced leaves, animals and human faces parallel the art of the West Coast Native peoples where eyes, faces and bodies of different animal and human forms flow in and out of each other. Even in the austere world of Islamic art, where figurative representation is for the most part prohibited, the face can be found in miniature paintings. From the eyes on Nepalese temples to ancient Assyrian carvings, from totem poles to Mayan and Egyptian stonework, the face is as universal as the sun, the moon, the stars, and the spiral.

The Pemberton Holmes building at 1000 Government Street in Victoria was designed by Thomas Hooper for C.A. Vernon, and constructed in 1900. It is believed that Vernon, founder of the B.C. Pottery Company, provided the fanciful faces and decorative floral motifs of terra cotta capitals around the ground floor and third floor. These make a connection with the Weiler Building,

Ormidale, Vancouver

just across the street, and Hooper continues this reference with the large arched windows around the third floor.

Close to the Woodward's department store in Vancouver we find this ornate gem of a building known as Ormidale. It was constructed in 1900 with money made in the Klondike gold-rush. Architect G.W. Grant was from Nova Scotia, and made original use of the Neo-Romanesque in this building. A row of arched windows on the top floor is punctuated by an oval window above the name Ormidale. The distinctive oval window is fairly well known to people in the city, but few seem to notice the row of heads up near the roofline. They add a medieval feeling to this very Victorian building, suggesting decorations from an old Gothic or Romanesque church. The whole facade is the rich red colour of unglazed terra cotta and brick.

The British Columbia Provincial Legislature, (or Parliament Buildings), is an imposing and dignified structure which, along with the Empress Hotel, defines the character of Victoria's inner harbour. These Parliament Buildings are historically the third administrative centre in Victoria. This handsome edifice replaced a cluster of buildings whose quaint design had earned them the apt nickname of "The Birdcages."

A bold young architect just recently ar-

Pemberton Holmes Building, Victoria

Parliament Buildings, Victoria

Parliament Buildings, Victoria

Parliament Buildings

rived from England, won the contest held for a larger and more dignified building. Francis Mawson Rattenbury used some Neo-Classical elements in his design, notably the copper domes; but the powerful massings of stone throughout are what really characterize the Romanesque Style. Thomas Hooper had already introduced Henry Hobson Richardson's powerful synthesis of the medieval Romanesque Style with contemporary architecture to Victoria several years before Rattenbury had won his first commission.

The buildings of both Hooper and Rattenbury were distinguished by a profusion of finely carved details throughout. There are many stone carvings around the building, like these bizarre faces posing as capitals on the tops of window-columns: birds, lions, dogs, and a plethora of scary looking ghouls and monsters, and many intertwined floral arabesques.

Rattenbury was typical of Victorian architects in making use of the architecture of other times as a sort of vocabulary of styles to be used and combined where appropriate: his use of Romanesque carving around the buildings makes no real reference to religious allegory, the original source of these eccentric capitals. Though this was his first major commission, his use of these devices appears to be simply a matter of the completion of a certain style. He could also, of course, have beem making a wry comment on the nature of the debates which he could foresee taking place in this building.

Parliament Buildings

Parliament Buildings

Hidden Cities

The first major contract that Rattenbury gained after the Parliament Buildings was for this fine Bank of Montreal. This was the first major eastern bank to head all the way west (1887)—no coincidence as the Bank of Montreal was the major backer of the Canadian Pacific Railway. The use of the Chateau-style was perhaps no accident either, as it was the C.P.R.'s semi-official style. It was a fine prelude to the grand use Rattenbury was to make of it with the Empress Hotel.

Sitting at 1200 Government Street (now

Bank of Montreal Building, Victoria

Bank of Montreal Building, Victoria

a Ralph Lauren Store), this unique structure is dwarfed by the Post Office beside it, yet its high peaked roof and beautiful stonework still make it stand out. The exterior is composed of granite from Nelson Island and Haddington Island stone. The Victoria firm of McGregor and Jeeves were the stone masons. There is a lot of fine stonecarving to look at here, though some of it is a long way up. The lovely face entwined with floral motifs makes a friendly counterpoint to the gargoyles at the top of the building.

The face shown here on the keystone of the arched front window looks like Lucifer's second cousin. Rattenbury would use a very similar face for a keystone above the entrance to the Legislative Library over ten years after designing this 1896 building.

Keystone, Legislative Library, Victoria

Sun Tower, Vancouver

The Sun Tower is graced by nine muses for inspiration, but it also has another, somewhat more macabre, detail up near the top of the building. Occuring on each of the building's six sides are these animal skulls surrounded by fruit and flowers. It could be the skull of a dog or a wolverine, but whatever it is, there is no explanation for its eerie presence. In Europe old churches sometimes have sculptures of skeletons doing the dance of death, and in Mexico the skull is a familiar sight in folk-symbolism, but it is rarely found in Canada.

Elsewhere in Vancouver are many unsettling faces just hidden from view. This peculiar fellow is among one of two trios of demonic faces found near the roofline of the north and east sides of the Carnegie Centre. There is a strong invocation of the polar giants that blow the icy winds from the North and South Poles. We have here the same configuration as the Hotel Vancouver: a regal lion above the entrance, and these weird creatures functioning up above as gargoyles. They look out across Main and Hastings Streets.

Carnegie Centre, Vancouver

Kensington Place, Vancouver

Kensington Place at 1386 Nicola Street at Beach Street looks out across English Bay. This Italian Villa Style apartment block was built for the wealthy in 1914. The structure was so lavish that at one time all the suites were equiped with dumbwaiters. The main entrance is a Baroque extravaganza capped by this horned face. This utterly unique West-End structure was rescued from demolition in the 1970's and renovated in 1980. The original architect was Philip M. Julien.

We can find these exquisite pieces of stone carving on a stroll from the inner city of Vancouver down Water Street. They are meant to represent the different races living in British Columbia at the turn of the century. Constructed between 1901 to 1905, the Greenshields Building was built in a modern Romanesque Style, and bears a similarity to Henry Hobson Richardson's influential Marshal Field Wholesale Store in Chicago (1885-87). Greenshields and Company were dry goods merchants, and this building provided warehouse and office space for them.

Greenshields Building, Vancouver

One can distinguish an African face, and several European faces including this bearded Spanish or Portuguese face. There are also a couple of "Indians" to be seen here, though, as usual, the incredibly rich decorative style of the West Coast Natives was ignored by the designer. In Europe at this time perceptive artists and designers synthesized such different styles as Japanese woodblock prints and Celtic interlace patterns, and Renaissance printers' ornaments into the Arts and Crafts, and Art Nouveau Styles, but colonial Canada saw no such inventive feats. European and American styles were simply imported and applied. The carved decorative motifs seen here are perhaps Vancouver's best example of the Arts and Crafts Style.

Greenshields Building

Renaissance printers' ornament

Greenshields Building

Greenshields Building

Greenshields Building

Though we do not know who designed the building, there is a strong possibilty that it came from the hand of one of the Victoria-based architects who had been inspired by the east-coast American architect H.H. Richardson. This building is one of our finer examples of Richardsonian Romanesque Style with its rough hewn stone around

Greenshields Building

the base, decorative carving, and the row of arched windows up above.

Perhaps the plans and designs for this building, along with so many others went up in flames in the 1910 Five Sisters Block fire in Victoria.

Hidden Cities

Carnegie Library, Victoria

In addition to its swirling relief dragons the first Victoria Public Library has an intriguing carved face staring out from a window capital. This and many other Romanesque touches connect this building stylistically to the Parliament Buildings. The building is now a Credit Union, and with all these powerful guardians watching over them, the accounts here should be very secure.

Greenshields Building, Vancouver

The Greenshields Building on Water Street in Vancouver's Gastown has a very similar face both in its appearance and in its location, on the second floor of the building façade.

We find other slightly less charming faces in a row of imps who scowl down at

Imp face, Victoria

pedestrians from 655 Fort Street in Victoria. The imp is a creature from the Middle Ages, a lesser demon who might be conjured up by an evil magician or a witch.

If you walk across the Burrard Street bridge in Vancouver you might notice these slightly ghoulish-

looking faces as capitals on the columns, around the middle of the bridge. They are Charles Marega's artwork, like the row of lions elsewhere on the bridge.

Burrard Bridge, Vancouver

The Hotel Vancouver is the home of this finely chiseled face. There are two of them on the north face of the building, just above street-level.

Hotel Vancouver

Sikora's Records, Vancouver

Street in Victoria you can see this face of a man who has the air of some explorer out of the past. It could be Captain Cook, to whom it bears a vague resemblance. The designer of the building was A.A. Cox, and it was built in 1912. Originally called the British American Trust, its name was changed to the Yorkshire Trust; but it has now been stripped back to its original stone, and the British American Trust logotype is once again evident.

London Building, Vancouver

An interesting music store with a guardian head above it is Sikora's Classical Records, at 432 West Hastings Street. This is a rather eclectic building, with its big arched windows and the peculiar row of stunted columns along its roofline. There are a couple of smaller, angelic looking faces on either side of this bearded gent. All three of them give a touch of the Middle Ages to this circa 1900 building, quite appropriate for its present use.

One of three carved stone panels on the front of the London Building at 626 West Pender Street contains this ornately carved detail with a smiling young face. The structure was built for the London and British North America Company in the Edwardian Commercial Style. Architects Somervell and

Putnam made use of the popular granite from Haddington Island (which is just north of Vancouver Island) for the facade of this ten-storey 1912 structure. The stone has been carved beautifully, as can be seen by the fine work evident here.

On the top of a quirky Edwardian Classical temple bank at 737 Fort

British American Trust Building, Victoria

Kelly's Music World, Vancouver

Take a look at this venerable curly-headed fellow and his two identical brothers who look down from an otherwise plain brick building at 820 Granville Street. The building dates back to 1913, and was designed by architects Braunton and Liebert. It was the Allen Hotel from 1924 to 1972, and today provides store and office space for Kelly's Music World. Above each of these three heads is an interesting pome-

granate motif. The pomegranate has been used since antiquity as a symbol of fertility, regeneration and immortality. The bright red colour was used by Christians to symbolize the blood of Christ. A connection might be found between this motif and the theatre next door. There has been a theatre next door since 1920, the date of the original Capital Theatre. The pomegranate was connected to Dionysian ritual, which was regarded as the birthplace of Greek, and hence Western, theatre.

Moving to a slightly less exalted level of religious imagery, the stonecarvers who decorated the Hotel Vancouver placed several of these grinning sprites on the north face of the building on West Georgia Street from where they observe the city traffic. One can see them located just a little bit above street-level.

Hotel Vancouver

Main at 16th Avenue in Vancouver is the location of a French Neo-Classical gem with a steep-pitched Mansard roof, and a clock tower. It was designed by the English architect Archibald Campbell Hope, who was the designer of a number of buildings in Vancouver after moving here from San Francisco. It now sports the appropriate name of Heritage House, but it began life as one of the most elegant looking Post Offices on the west coast of Canada. It has a variety of interesting faces around it, smiling young ladies, stern old men, and the fellow with the peaked cap who could represent a postie on the job.

Renovated through the mid-eighties, this building has had a fascinating history. It began life as Postal Station C in 1915, in a part of the city that was expected to grow into an important business district. This growth-boom failed to materialize, and, in 1922 the Post Office was scaled down to make room for the Department of Agricul-

Heritage House, Vancouver

Heritage House, Vancouver

Heritage House, Vancouver

ture to share it. The Post Office lasted until the 1940's, and the Department of Agriculture used parts of the building for a seed lab, and the second floor as a morgue for animals. They moved out in the early sixties, and after sitting vacant for a few years the R.C.M.P. moved in, in 1965. They used the building as a special investigation branch, mainly for wire-tapping operations. They moved out in 1976, and it sat empty and vandalized until Mount Pleasant groups took an interest in bringing it back to life as a heritage building. We must be thankful for their efforts, as this is a unique and beautiful structure. The City of Vancouver purchased it from the Canadian government in 1982, and after extensive renovation it was reopened as a cultural centre in 1983.

Heritage House, Vancouver

Hidden Cities

By the lawn in front of the Vancouver Art Gallery on West Georgia Street is a princely fountain with a mosaic-tiled basin and many small sculptures carved out of a large piece of black marble. This fountain was the B.C. Provincial Government's gift to Vancouver in 1966, on the occasion of the City's 80th birthday. It was created at a cost of $300,000 by Count Alex von Svoboda, an Austrian born count, who resided in Toronto for many years. There is a mermaid, a woman's face, a sword, a lizard, and an old man's face peering out from the rough marble as the fountain splashes down on it.

Art Gallery lawn, Vancouver

Art Gallery lawn, Vancouver

New Westminster born Samuel Maclure was the architect of many fine B. C. homes, the majority of them being located in Victoria. Across the water, in Vancouver, he was commissioned to design a spacious mansion for sugar baron-Benjamin T. Rogers. Gabriola, at 1531 Davie Street in the West End, was named for the sandstone quarried from Gabriola Island, and used extensively around the exterior. The soft stone carved beautifully, and there is a near-continuous Art Nouveau frieze round the building. Lions, eagles, dragons, cherubs, grinning faces, and sinuous vegetation flow in and out of one another. The ornate Sullivanesque style used by Maclure for his Temple Building in Victoria has here given way to the European Art Nouveau Style more frequently seen in Vancouver and Victoria at this period.

The strong horizontal lines of the building showtrends which came from American midwestern architecture which would later be explored and developed by Frank Lloyd Wright.

Gabriola is currently home to a luxury restaurant known as Hy's Steakhouse, the owners of which have endeavoured to preserve the heritage values of this building.

Gabriola, Vancouver

Gabriola, Vancouver

Gabriola, Vancouver

Gabriola, Vancouver

Gabriola, Vancouver

Hidden Cities

Gabriola, Vancouver

At 525 Fort Street in Victoria stands a small, exquisitely decorated red structure. Known as the Temple Building, it is a unique example of the style and theories of the American architect Louis Sullivan. The first commercial building of Victoria architect Samuel Maclure, it was designed for Robert Ward and Company who had a number of commercial interests in the city. The building provided office rooms, and space for storage, for their import-export business.

Rich ornamentation and the evocative name of the the Temple Building may seem a paradox as adornments for a commercial

Temple Building, Victoria

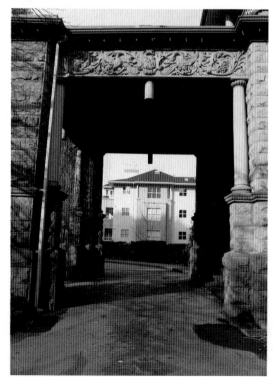

Gabriola, Vancouver

building, but this conjunction follows the direct influence of Louis Sullivan on Maclure's architecture. Though one of the pioneers of the skyscraper, he believed, following the lead of the Arts and Crafts Movement and its European counterparts, that there should be a combination of the artistic and the utilitarian in all architecture. By combining the inorganic, crystaline forms of the straight, vertical lines of a tall structure (made practical in the 1880's by the development of elevator technology and steel frame construction), with ornamentation derived from organic forms, as evidenced in printer's ornaments such as the one below, the skyscraper took on an almost mystical significance as an *objet d'art* which transcended its day-to-day use.

In addition to Arts and Crafts/Art Nouveau influences, Sullivan was also inspired by Swedenborg, and further by the decorative/symbolic significance of Islamic sacred architecture. For him any building could be a temple, a philosophical statement on "the graciousness of higher forms of sensibility."

The swirling arabesques of floral ornament from which peer these grinning and grimacing faces, all in the natural red of terra cotta, match the red of the pressed brick on the upper part of the building. The base is of rough-cut sandstone. Under a fantastically decorated archway, the main entrance is framed by two polished pink pillars of granite. The building presently houses the Victoria Chamber of Commerce.

Temple Building, Victoria

Printer's ornament

Hidden Cities

Part Five

History & Allegory

Back as much as 5000 years to the ancient Mesopotamian civilizations of Ur, and to the early Egyptian civilization one finds sculptures of heroes and allegorical figures associated with architecture. Proud rulers erected images of themselves in search for immortality in stone or metal, and to this day heroic deeds and important individuals are commemorated with statues. Religious architecture has almost always displayed idols and allegorical symbols in human, semi-human and animal form. The technical skills and accurate modelling required of a sculptor to recreate a human form meant that unlike the face, which could be evoked with no more than a few lines, a statue was reserved for privileged individuals, or their descendants, and wealthy institutions.

While the designers of the two cities under discussion depicted "Indians" usually as supporters for distinctively Canadian coats of arms, they were only capable of supplying Eastern stereotypes, in this case the tomahawks and feathered headdress "Indians" of Plains and Eastern woodland tribes. They clearly considered that, despite the evidence around them, the "Indians" on the west side of the Rockies were no different from those on the east side. No doubt the control of Eastern bankers and developers over the growing colonial economy of British Columbia, in which the local Native population held no place, had a great deal to do with this failure of vision on the part of the architects and builders of British Columbia. With only a single exception, none of the heritage buildings in either Vancouver or Victoria shows any awareness of the incredibly rich decorative vocabulary of the B.C. Native Peoples. In the context of such a formidable sculptural and decorative tradition, it is shocking to see how utterly absent their work is from the inner cities—with the exception of the Kwagiutl pole outside the C.B.C. bulding, and the interior of the Royal Bank at the Royal Plaza in Vancouver where, on the walls of the second floor, are several large, superbly carved wooden panels created by Gitk'san (Tsimisian) artists.

Both the skyscraper and the totem pole are based on the principle of greater height equals greater prestige. Someday perhaps a bold innovative developer or architect in Vancouver or Victoria will see how perfectly Western Native artforms wrap surfaces. When they make that leap forward we could have an architecture unique to this part of the world.

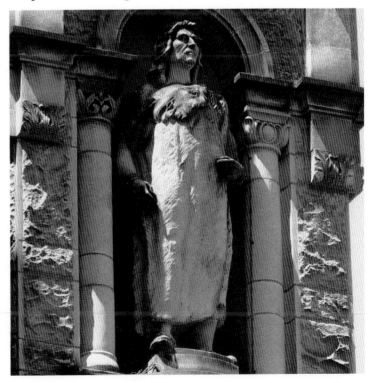

Hidden Cities

Victoria's Parliament Buildings have already been mentioned as a treasure-trove of sculpture, and probably the richest part of it is on the library wing, at the back of the building. Fourteen very realistic life-sized sculptures of prominent figures from British Columbia's history look down from niches set in the upper corners of the building. They were designed and created by Vancouver sculptor Charles Marega, who obtained the commission not long after his arrival in B.C. in 1910.

The list of figures is as follows: Ocean explorers Sir Francis Drake, Captain James Cook, and Captain George Vancouver, land explorers Sir Alexander Mackenzie, David Thompson, and Simon Fraser, early administrators Colonel Moody, Lord Lytton, Sir Antony Musgrave, Sir James Douglas, Dr. John McLoughlin, Sir Matthew Baillie Begbie, Dr. John Sebastian Helmcken, and a Native leader, Chief Maquinna.

The sculpture of Chief Maquinna is unique, being a representation of an actual West Coast Native, and not a stereotyped Colonial invention, as is seen in every other heritage example. The instance of any Native leader in Colonial architecture and sculpture is comparatively rare throughout the world, which makes the presence of Maquinna here a very significant example.

Maquinna was an exceptionally intelligent and adroit leader, skillfully playing off the loyalties and demands of the British against the Spanish, as they sought possession of Vancouver Island and the continent beside it. He was a commanding figure who spoke Spanish, French and English, and came to successfully control the sea-otter pelt trade, which attracted an increasing number of Europeans and Americans to the Pacific Northwest. In fact, it became customary for European ships approaching his town of Yuquot to fire a salute to Maquinna.

Maquinna was hereditary Chief of the West Coast (or Nootka) Mowachaht tribe. He is believed to have met Captain James Cook on the British navigator's voyage up the Northwest Coast in 1778. A European account of life among the West Coast peoples was written by a British ship's armourer named John Jewitt, who was retained by Maquinna for his metalworking skills. He published a narrative of his years with Maquinna and his people after he returned to Britain, and it is quite possible that Rattenbury may have encountered and read it before setting foot on the Northwest Coast.

Maquinna is shown here dressed in animal skins. Sculptor Marega was aiming for a high degree of realism in these statues. Wherever possible, he tried to catch the likeness and demeanor of his subjects. We recognize the better known figures at a glance.

While Marega succesfully captured the

Sir Francis Drake, Provincial Legislative Library

Chief Maquinna

proud, strong face of Maquinna, he unfortunately neglected to include some aspect of the superb and original decorative styles of the West Coast Native Peoples. The rich vocabulary of chevron shapes and animal forms which found their way onto most clothes and artifacts of the nations of the Pacific Northwest is absent here. In particular, he missed the distinctive whaling hat worn by Maquinna, although this may have been due to the size of the niches intended for the sculptures. The conical cedar and swampgrass hat which Chief Maquinna wore was decorated with canoes, hump-

Judge Mathew Baillie Begbie

back whales, and whalers wielding long harpoons.

Since Marega had no records of the appearance of the explorer and fur trader David Thompson, he was forced to use another appropriate model. He created the figure of Thompson after the likeness of John Bunyan, the 17th century British author of *Pilgrim's Progress*. It must be noted, however, this is the only exception to the historical accuracy of the depictions in this sculptural group.

Here is a statue of Sir James Douglas who, after having been the first Governor of Vancouver Island, became the first Governor of British Columbia as the Fraser River gold rush of 1858 brought waves of prospectors into the new colony. He had a reputation as a hard man, but was a tireless administrator in a time when the Colony was a reckless and often lawless frontier.

A contemporary and co-worker of his, Sir Matthew Begbie, came from England at about this time to create and administrate a legal system for British Columbia. Like Douglas, he was known as a stern and at times a harsh man. As the head of the justice system, he was at times known as the "hanging judge."

Sir James Douglas

Provincial Legislative Library, Victoria

Bank of Montreal, Vancouver

Bank of Montreal, Victoria

The Bank of Montreal's coat of arms for many years consisted of a pair of "Indians" shown lounging on either side of a shield with the inevitable beaver perched on it. This passive pose was, at least in part, used to make a triangular shape to fit the gable of the building.

One should, however, question whether this image represents the "lazy Indian", a stereotype developed by European colonists who reported little success across the continent in their efforts to enlist the native population in the labour of their own exploitation. The one shown here is at 390 Main Street, at the corner of Hastings Street, in Vancouver. It was designed by the firm of Honeyman and Curtis, and built during 1929 and 1930, one of the last temple banks constructed in Vancouver. An almost identical crest can be found on the Bank of Montreal's Granville and Pender branch in Vancouver, and its Yates and Douglas branch in Victoria. These were undoubtedly added at a later date to both banks, as they were both originally designed for the Merchants Bank, absorbed by the Bank of Montreal in 1921.

Among the many stone carvings around the Hotel Vancouver are these cameos of Plains and Eastern Canadian "Indians" just above street level on the eastern side of the building. This feathered headdress is quite detailed, and it is possible that the drawings for these faces of Canadian Natives were taken from actual historical figures.

Hotel Vancouver

Hotel Vancouver

Hotel Vancouver

Hotel Vancouver

tects, Mercer and Mercer. Born in 1905, Beatrice Lennie was a pupil of Charles Marega at the Vancouver College of Art, and carried on Marega's work of providing sculptural elements for Vancouver architecture, albeit in a style which was uniquely her own. Although some of her finest creations, notably one on the façade of Shaugnessy Hospital, and another inside the current Hotel Vancouver have been destroyed, there remains ample evidence of her talent. She served as President of the newly created Vancouver Art Gallery in 1932, and gave private lessons to many students. Beatrice Lennie died in 1987 at the age of 83.

Academy of Medicine, Vancouver

The Burrard Street exterior of the Academy of Medicine, located at 1807 West 10th Avenue in Vancouver, shows the figure of Hippocrates, the father of medicine. He is shown here holding a staff with a serpent wound around it in one hand, and a papyrus scroll in the other. The Hippocratic oath defined the creed of the healer, and, in spite of the great advances of modern medicine, remains no less valid today. The scroll contains ancient Greek medical texts, and the staff and snake (which are often confused with the Caduceus of Mercury) are known as the Staff of Aesculapius, a legendary figure of Greek medicine.

This 2000-pound relief sculpture was created with cement and marble dust by Vancouver sculptress Beatrice Lennie in 1951. She was commissioned by the archi-

The Labour Temple of the Trade Labour Congress displays a large relief mural in stone, created by B.C.-born sculptress Beatrice Lennie. She was commissioned by the Dominion Construction Company for this 1949 building on Vancouver's West Broadway. This huge project, over 6 feet high and 30 feet long, took her eight months to complete. It consists of five panels, and weighs a staggering six tons.

It contains, along with the main theme of raising labour to a heroic status, another note, like the Harding Memorial, of American influence on the development of British Columbia. On the extreme left of the panel two Canadian emblems—the maple leaf and the beaver—float above the letters TLC, Trade Labour Congress. On the extreme right is the American eagle. It has the entire North American continent behind it, and is emblazoned with the letters AFL, American Federation of Labour.

In the centre of the mural there is a huge riveted wheel supported by two muscular workers, focusing the dependence of both countries on the workforce. Within the wheel the theme of driving rivets is continued, refering to the skyscrapers and ocean-liner to the right. Two women sew fabric in the foreground, but the two other female figures are the most interesting. One holds her arms around the skyscrapers of a modern city and gazes down at it, while the other holds in her palm an airplane as though it were a big dragonfly.

Beams of light radiate from the wheel of industry, crisscrossing the paths of paratroopers in the background, while aircraft soar above them. These lines work to unite the two sides of this very long composition. Though a few parts of this mural are rendered naturally (notably the beaver), it is essentially an Art Deco design, as seen in the streamlined faces of the central figures.

Labour Temple, Vancouver

Labour Temple, Vancouver

Labour Temple, Vancouver

Labour Temple, Vancouver

The exterior of the Georgia Medical-Dental Building was a marvel of terra cotta ornament, and its demolition has already been lamented in this book. Its most prominent motifs were the three nurses which stood high up at the most visible corners of the upper façade. The three nurses were designed by three architects who were with McCarter and Nairne at the time: James Watson, C.Young, and J.D. Hunter. A small model was made by one of the architects, then later enlarged and modelled in terra cotta by the Seattle firm of Gladding McBean. Each nurse is twelve feet in height. They were carefully removed before the old building was demolished, and new fibreglass replicas made from the originals have been placed just above street level on the current building, Cathedral Place. The installation on the new structure reveals them to be composed of several large, hollow fibreglass sections, the nurse's hands being actually a part of the mount.

Once an integral part of a far more elaborate scheme of decoration, the nurses were originally far less visually prominent in their location near the top of the old

Cathedral Place, Vancouver

Cathedral Place, Vancouver

Hidden Cities

structure. The new placing makes viewing these once lofty sculptures possible without magnification. Though somewhat stylized, the designers have captured the compassionate face of a hard-working nurse and raised her to a heroic status.

Georgia Medical-Dental Building

Cathedral Place, Vancouver

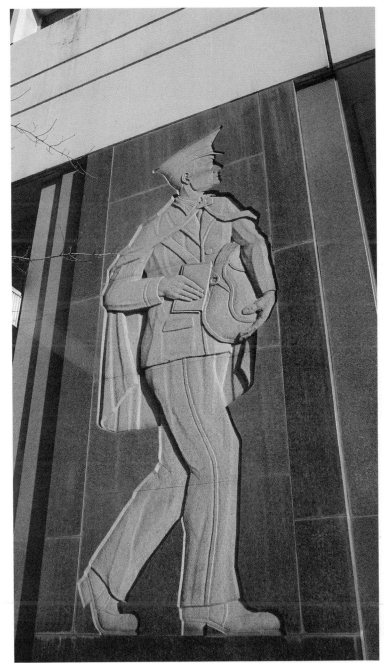

Vancouver's main Post Office, at 349 West Georgia Street, has a heroic figure of labour on its vast, though largely unornamented, exterior. At the south-west corner of the Richards Street side is a larger-than-life postman carved into a polished red granite façade. This work is executed in an inverse bas-relief, a sculptural technique favoured by the ancient Egyptians, though rarely seen today. Paul Huba, the sculptor, finished this work in 1956, two years before construction on the building was completed.

The City of New Westminster, though presently absorbed into the greater Vancouver area, was founded over two decades before the City of Vancouver. Although its streets possess many fine heritage buildings, few of them possess such fine sculptural elements as the Bank of Nova Scotia at the corner of Columbia and Begbie Streets. Constructed in 1928, it displays some superb architectural ornament. The Begbie Street side features these two panels, one depicting fishermen at work, the other showing loggers.

Though these are relatively small panels, the dynamic compositions and surging internal rhythms of both sculptures succeed in making great art out of these two primary B.C. professions.

Chief Post Office, Vancouver

Bank of Nova Scotia, New Westminster

Vancouver's Gastown is home to this fascinating collection of painted bronze heads with typical Gallic features. The closed eyes suggest that they may have been derived from the death masks of famous Frenchmen (there is one head which looks a lot like Paul Verlaine, and another who could be Charles Baudelaire). Situated at the foot of Homer Street, the arcade they decorate is called Le Magasin, which would support the idea. There seems, however, no record of this structure as Le Magasin, and no key to identifying the heads of these ten, perhaps illustrious, individuals. The location of the arcade corresponds to the Homer Arcade, which has always had both West Cordova and Water Street addresses—currently 397 West Cordova and 332 Water. It was built around 1912.

Driving across Burrard Bridge there are

Le Magasin, Vancouver

Le Magasin, Vancouver

Burrard Bridge, Vancouver

Burrard Bridge, Vancouver

a number of motifs which one might easily miss, but it is worth watching for these two jutting boat prows with prominent figures on them. They are on both sides of the Bridge's superstructure—the British explorer Captain George Vancouver on one side, and his friend, Captain Harry Burrard, on the other. Captain Vancouver sailed to the Pacific via the southern tip of Africa and the Indian Ocean in 1792. In a longboat he ventured into Burrard Inlet, naming it after a naval friend. His voyage into First Narrows showed the area to be part of the continent, and not a group of islands, as was previously reported by Spanish explorer José Maria Narvaez.

The present Parliament Buildings are many times larger than the previous structure, yet soon after their completion more room was wanted. At the back of the main complex there are several additions, the largest of which is the Provincial Library. Also designed by F.M. Rattenbury and constructed between 1911 and 1916, it features, among other things, six medallions of great literary figures, appropriate for a library. Along with Dante and Sophocles, there are also busts of Shakespeare, Socrates, Milton, and Plato. These were sculpted by Charles Marega, who acquired the $25,000 commission for the 26 sculptures to grace the Library addition.

Legislative Library, Victoria

Legislative Library, Victoria

Legislative Library, Victoria

Ranged along the roofline of the Provincial Legislature's Library are twelve female allegorical sculptures, among them this pensive figure of Law. These statues were sculpted by Charles Marega's assistant, Bernard Carrier as part of the extensive program of statues selected by F.M. Rattenbury for the new Library.

Legislative Library, Victoria

Hidden Cities

Part Six

Gods & Goddesses

The gods and goddesses of ancient Greece and Rome have been part of the building traditions of the Western world for over 2000 years. Even today, Classical elements hardly draw surprised reactions when found in contemporary art and architecture. There are many ancient deities to be found hidden in both Victoria and Vancouver.

Many of the Roman gods, whose names are generally more familiar to us, were derived from their Greek predecessors. For example, the god found most frequently in both cities is Mercury, who was adapted from the ancient Greek god Hermes, while Neptune was taken from the Greek god Poseidon. Other Greek deities such as Pan retained their names in Roman representations. Since ancient times mythological female figures known as caryatids have been used as architectural devices to support cornices.

These ancient religious figures became part of the repertoire of symbols used by Western writers, artists and architects sometimes in a purely decorative sense, but usually to illustrate some aspect of their creation.

For example Mercury, the god of commerce and travel, and Neptune, ruler of the oceans, were selected by banks, merchants and shipping companies all over the world as descriptive emblems.

Hidden Cities

The Sun Tower began life as the World Building in 1912. "The World" was a major Vancouver newspaper at the time. Though the newspaper was not an enduring success, its publisher, Louis D. Taylor, went on to become the Mayor of Vancouver — he was elected eight times.

This fine 17-storey structure succeeded the Dominion Building a few blocks away, as the tallest building in the British Empire, and held this honour until 1914 when a 20-storey bank was constructed in Toronto. The building changed hands in 1924, becoming the Bekins Building, the Vancouver headquarters of this North American moving company. It was the home of "The Vancouver Sun" newspaper from 1937 to 1964.

The building was designed by W.T. Whiteway, born in 1856 in Musgrove, Newfoundland, who began his Vancouver practice in 1896. An elegant six-sided tower with an ornate copper Beaux-Arts roof sits on a corner of a larger, more Richardsonian, base. A large glass globe, shown sitting at the top of the tower in the original plans, was excluded from the finished structure.

Sun Tower, Vancouver

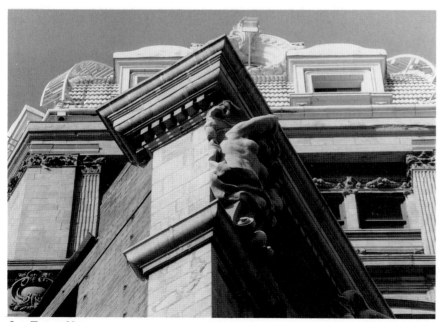

Sun Tower, Vancouver

The careful arrangement of the base, tower, and finely sculpted decoration make the Sun Tower a popular landmark in the city.

Around the top floor of the base, nine large terra cotta caryatids smile gracefully as they support the cornice of the base. Caryatids are traditionally somewhat more modest than these voluptuous maidens. Appearing out of billowing sashes of fabric, there is a suggestion of Art Nouveau here. They recall the arabesques in the drawings of Aubrey Beardsley, the posters of Alphonse Mucha, and the many sculptures created by numerous artists of the American dancer Loie Fuller, who fascinated Paris at the turn of the century with her clever orchestrations of movement, light, and fabrics.

It is generally supposed that the Maidens represent the Nine Classical Muses. These are ancient Greek images of artistic, cultural, and scientific inspiration which were later formalized by the Romans. They were said to be the daughters of Mnemosyne, the Greek goddess of memory, and Zeus, the father of the gods. The word "museum" is in fact derived from the Classical

academies devoted to the muses. The Romans identified them as follows: Terpsichore – muse of dance, Urania – muse of astronomy, Euterpe – muse of flute playing, Thalia – muse of comedy, Calliope – muse of epic poetry, Polyhymnia – muse of songs and music, Clio – muse of song and hymns, Erato – muse of lyric poetry, and Melpomene – muse of tragedy. These patron goddesses of the arts seem an appropriate group to inspire newspaper writers and graphic artists of the early part of this century.

Quebec Manor, Vancouver

ing ships. On closer inspection there are flowing wings behind them, suggesting Art Nouveau angels. Though these are somewhat closer to the ancient model of caryatids in that they are supporting a Classical pediment above the entrance, the "modern" ideals of Art Nouveau allowed bare-breasted women to decorate a temple façade. Constructed in 1912, the building was designed by the Vancouver firm of Townsend and Townsend.

Sun Tower, Vancouver

Located at 101 7th Avenue, near Main Street in Vancouver, there is a strikingly original building known currently by the name of Quebec Manor. Known as the Mount Stephen Block until 1964, it is a four storey apartment building with patterned brick-work, fancy wrought-iron balconies, and two lovely, smiling goddesses reminiscent of the ornaments once found at the bows of sail-

Quebec Manor, Vancouver

Vancouver Block

the cornice at the roofline of the main structure. They are clad in Classical Greek clothing. The Vancouver Block is not a tall building by contemporary standards, but these caryatids along the top of it are almost impossible to see from the street. It is just possible that the architects were inspired by the angelic caryatids at the top of some of Louis Sullivan's skyscrapers. The term "caryatid" is a Classical term which comes from the women of Caryae, an ancient Greek town where a festival was held in honour of the goddess Artemis. The women would do ritual dances in her honour, and these dances became a popular subject for sculptors, eventually becoming part of the visual vocabulary of the Classical temple, holding up the entablature, or triangular gable at the front of the structure.

Vancouver Block

For many years after its completion in 1912, the Vancouver Block was a local landmark. The ornate four-sided clock which crowns the building was visible for many miles, and no doubt helped many people arrive on time in an era when radio and television were still science-fiction. Designed by architects Parr and Fee, the building's façade is covered with white glazed terra cotta. At 736 Granville Street, it is now overshadowed by a bland adjacent highrise on the spot where the beautiful Birks Building formerly stood.

A row of terra cotta caryatids hold up

Vancouver Block

Dominion Building, Vancouver

The Imperial Trust Company hired architect J.S. Helyer to design the stately Dominion Building, at the corner of Hastings and Cambie Streets in Vancouver. During a site inspection Helyer fell, and, as a result of this fall, died before the building's completion. Fortunately, his son carried on his work and finished the job. Imperial Trust had merged with the Dominion Trust by the time of the building's completion. Constructed between 1908 and 1910, it is a handsome red and orange structure with scroll-like ceramic ornanents running up its sides, and a Mansard roof. Renova-

tions to the building, timed to coincide with the buildings 80th birthday, revealed a pair of Cupids (Cupid was the Roman adaption of the youthful Greek god of love, Eros) under a restaurant sign at street level, a rare archeological find in modern Vancouver. Jackson's Beef House is still there, but their sign has remained down, and the Cupids have a new coat of paint.

It is a real pleasure to wander the inner streets of Victoria. The well-cultivated colonial air of the city can transport one back in time. Hardly a church in Europe was built for hundreds of years without either a painting or some carvings of cherubs in, on or around it. The tradition did not really

make it to the West Coast as a significant ecclesiastical motif, but on the side of what is now a St. Vincent de Paul second-hand store is a sweet, angelic face. The word "cherub" is derived from cherubim, originally an angel with three pairs of wings. In centuries of representation, these angels have become confused with the small, winged love gods known as putti, or amorini, themselves derived from Eros. The Italianate style building that these cherub heads adorn was built in the 1880's as the Oriental Hotel. The main structure was constructed in 1883, and other parts were added to it later. Located at 550 Yates Street, the architect was John Teague, who also designed Victoria's City Hall.

Oriental Hotel, Victoria

Holden Building, Vancouver

chandise," are all derived from the word Mercury. Many of the stories and attributes of Mercury are taken from the Greek god Hermes, who had winged sandals, a round messenger's hat, and a caduceus, or messenger's staff.

Messengers in ancient Greece

Holden Building

The Holden Building, at 16 East Hastings Street, features a pair of Classical gods, Mercury and Vulcan. Developer William Holden employed architect W. T. Whiteway for the design, and it was erected 1910-1911, just prior to Whiteway's work on the Sun Tower. This elegant early office tower functioned as Vancouver's City Hall between 1929 and 1936, when the City Council moved to its current Art Deco home at 435 West 12th Avenue. Among the original tenants of this building were the Molson Bank, and a number of mining companies. A long tradition in Western architecture associates Mercury with banks and merchants, while the connection of Vulcan was with metals and their working.

Mercury was the messenger of the gods in Roman mythology, and the god of roads and travel, communications and commerce. In fact the words "commerce" and "communications," along with "merchant" and "mer-

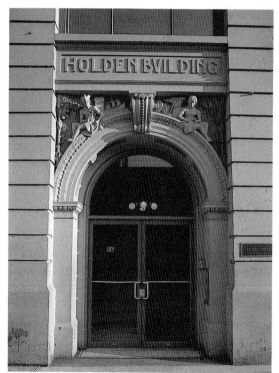

Holden Building

would carry an olive branch to guarantee recognition and safe passage. The wings on the caduceus were added with the same intended symbolism as those on the sandals and hat of the god to convey Mercury's incredible speed. An ancient myth recounts how Hermes came across two snakes entwined in battle and separated them with his staff. They were added to the caduceus to symbolize Hermes (and Mercury) as the arbiter of disputes.

Vulcan is the god of fire, metals and blacksmiths. He was adapted by the Romans from the Greek god Hephaestos. Vulcan was the only god with a physical imperfection—he was lame. In spite of this he was the husband of Venus, the goddess of love. There are many myths concerning Vulcan's jealousy over her affairs with other gods, such as Mars, the god of war. The lameness of Hephaestos and Vulcan coincides with other Indo-European gods of fire

and metal-work, who suffered from the same disability. The origin for this near-universal lameness of the smith was the importance of metal-work in the early Bronze Age. Rulers were prompted to deform or disable their smiths to make them dependent, and unable to leave to serve their enemies. In the 20th century this is accomplished by high-paying positions, exclusive contracts, and dental plans.

Vulcan (complete with anvil and hammer) and a reclining Mercury are looking good here after a recent paint job. Both watch over the tenants of the Holden Building as they enter and leave it. Mercury is seen on more buildings than any other deity in Vancouver and Victoria. The association with money, merchandise and travel corresponds with the construction of these buildings for banks and traders. While this is the only instance of Vulcan appearing in either city, he is a perfect symbol for the many mining concerns in British Columbia. The building currently goes by the name of the Tellier Tower.

In Victoria, at 1022 Government Street, the winged head of the god Mercury looks down with a benign air. He is always portrayed as a youthful and athletic god. Built as the Bank of B.C. in 1886, this building is currently the home of a Canadian Imperial Bank of Commerce. Bearing no relation to the one operating in British Columbia today, which is a division of the Hong Kong Bank of Canada, the early Bank of B.C. played a major part in bringing the colony of Vancouver Island into a union with British Columbia, and later Canada. It was

Bank of British Columbia, Victoria

absorbed by the Bank of Commerce in 1901.

Designed by architect W.H. Williams of Portland, Oregon, it is an intricate, yet beautifully proportioned, building. Each of its three storeys are quite distinct. The bank was created in the Victorian Italianate Style, an allusion to the great Florentine banking houses of the Renaissance period.

We see Mercury's head here on either side of the beautiful carved stone entrance to the Royal Tower, at the corner of Granville and Hastings Streets. He has a mermaid and a winged lion for companions. Here, to the association of Mercury with money and trade was added the watery symbol of the mermaid, appropriate for a city whose wealth derived largely from sea trade. The lion is an emblem of both B.C. and the Royal Bank.

Royal Bank Tower, Vancouver

Granville Cinemas, Vancouver

Harding Memorial, Vancouver

An exotic Art Deco Terpsichore floats above cinema patrons at 851 Granville Street. There has been a theatre at this location since the beginning of the 1920's, when the Globe theatre was constructed. It was either demolished, or more likely rebuilt in 1938, when this muse of dance, and her neon accompaniment appeared with the Paradise Theatre. During the 1960's it was renamed the Coronet, and in recent times it has been preserved as part of the Granville Cinema complex.

Another exceptional work by sculptor Charles Marega is the Harding Memorial, created to commemorate the visit of American President W. G. Harding to Vancouver in July of 1923. It was erected by Kiwanis International in 1925, as this was not only the first visit of an American President to British Columbia, but also to Canada as well, during his term of office. Canada had been America's neighbor for 56 years, and become a major trading partner: this was a significant occasion. An inscription on the granite shafts records part of his speech. Marega created a noble and dignified symbol for the peaceful coexistence of the two countries. Two bronze maidens in Classical Greek garb face each other across a polished granite pillar in whose center is a relief silhouette of President Harding. One maiden leans on a star-covered shield while extending an olive branch to the other, herself leaning on a shield bearing the British flag.

Harding Memorial

This jovial old fellow is one of several matching faces of Neptune on a large temple-style building, a short distance from the grounds of the Parliament Buildings in Victoria's inner harbour. Designed by F. M. Rattenbury as a Beaux-Arts Temple of Neptune, it seemed appropriate for the Canadian Pacific Railway's western Steamship Terminal. Rattenbury's engineering partner, P.L James, here made the first use of pre-cast concrete in Victoria. The frozen grin on the face of Neptune is appropriate today as the building is currently a Madame Tussaud's Wax Museum.

Madame Tussaud's, Victoria

Royal Theatre, Victoria

The Royal Victoria Theatre was designed by William D'Oyly Rochfort and E. W. Sankey for three prominent Victoria businessmen who planned to make it the Victoria Opera House. Before the opening the name was changed to the Royal Victoria Theatre. Built in 1913 at 805 Broughton Street, it has a sumptuous exterior worthy of an opera house. A huge expanse of decorative brickwork is set off by numerous ornate terra cotta details, many of them from Classical mythology, like this grinning satyr. Opera houses and theatres have always used figures of Greek mythology, the connection being easy to make with the birth of theatre. The building was run as a movie house for many years, and is now a community centre for the performing arts.

401-403 West Cordova Street, Vancouver

Pan is the ancient Greek god of woods and pastures. We can see here his horns (being half goat and half man), and the leafy green beard, which was one of his other attributes. Pan had a wild and capricious nature, and the words "panic" and "pandemonium" are both derived from his name. At one time known as the Queen Anne Hotel, this building dates from 1899, and is another fine example of the Richardsonian Romanesque Style. Although the architect is unknown, it points once again to Victoria, and the architects of the Five Sisters Block. It is located at 401-403 West Cordova Street in Vancouver.

Pan's companion, on the other doorway, this venerable bearded gentleman who could be Zeus, or Neptune, looks down from the keystone above the doorway of this grey stone Gastown building. With the demise of stone masonry as part of building construction, the ancient stonecarving tradition has vanished from contemporary use. As the European traditions of the construction industry gave way to the skyscraper's steel, glass and concrete shortly after the turn of the century, we are fortunate to have such wonderful examples of it remaining in Vancouver and Victoria.

Though a different address, 342 Water Street, this is the same 1899 building that sports the two gents on the facing page. Her lovely face gazes upwards from the keystone, but in the curls of her hair you can see the serpent heads that are Medusa's trademark. Medusa was a monster from Greek mythology. She was one of the three Gor-

401-403 West Cordova Street, Vancouver

342 Water Street, Vancouver

gons, but the only one who was mortal. They were transformed by the goddess Athena for boasting of their beautiful hair. Athena turned their hair to snakes and gave them long fangs and staring eyes. Anyone who looked directly at them would be turned instantly to stone. Medusa was killed by Perseus, who looked at her reflection in a mirror, and cut off her head. Athena then took the Gorgon's head and fixed it to the breastplate of her armour.

Among the many exquisite carvings to be found on the archway which serves as an entrance to the Royal Tower, located at the corner of Granville and Hastings Streets, is this finely chiseled aquatic deity. The lower half of her body coils up behind her in a fishtail, while with her muscular arms she pulls up behind her a pair of sea serpents. This powerful act seems in stark contrast to the serenity of her facial expression. While the figure of the mermaid is traditionally used to represent the gentle and benign aspects of the oceans, this particular image reminds the viewer of the raging and dangerous forces always present just beneath the calmest waters.

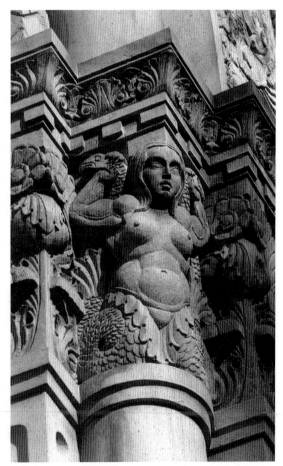

Royal Tower, Vancouver

Hidden Cities

Bank of Toronto, Victoria

A building at the corner of Broad Street and Yates Street in Victoria has a corner entrance with an interesting window above it. This fanciful couple, consisting of yet another Plains Indian out west, and a warrior-maiden, stand atop a scroll declaiming the motto Industry, Intelligence, Integrity. The Native Chief has the obligatory tomahawk and headdress, though the feathers are an odd shape, resembling leaves more than feathers. This building, which dates to 1923, was originally a Bank of Toronto. There is a strong similarity to the Bank of Montreal emblem, with its "Indian" as a supporter, and the beaver which sits directly above the window.

The image of Britannia was modelled after the Greek deity Athena, originally the strong and intelligent mentor of Odysseus, and goddess of the people of Athens, daughter of Zeus. Goddess of the waves, Britannia was a symbol of the British Empire's supremacy at sea. In one hand she holds a trident, alluding to the sea god Neptune. Mounted on her armour is a round medallion of a lion, and by her side a shield with the St. Andrew's cross — used on the British flag — emblazoned across it.

At 805 Gordon Street, just across from the Empress Hotel in Victoria, the Union Club is an attractive Neo-Renaissance building. This exclusive gentlemen's recreational centre was designed by Loring P. Rexford of San Francisco. His three-storey Florentine Palazzo design was selected from 17 entries to a contest for a new building. A real estate boom in Victoria had increased the membership of the club so much that

Union Club, Victoria

Union Club, Victoria

the old clubhouse at Douglas and Courtney Streets was no longer of sufficient size. The second Union Club building was constructed in 1912. Cream-yellow terra cotta decoration, featuring these cherubs with spiral tails and other Classical motifs add a fine Renaissance touch.

Another pair of cherubs, this time with dainty little wings, look out from the richly decorated exterior of the Royal Theatre, in Victoria. Located on Blanshard Street, across from Broughton Street, this 1913 theatre displays numerous fine terra cotta decorations, many of them refering to Classical themes. Between the cherubs are two overflowing cornucopias and an ancient Greek mask of comedy, with a curling beard and a big cut-out mouth.

Royal Theatre, Victoria

Hidden Cities

Part Seven
Classical Motifs

Even now, in the late 20th century, in cities half a planet away from ancient Greece and Rome, we have tangible reminders of the brilliance of these two early European civilizations. Ancient Greece was the real origin of the temple style that has returned to fashion in numerous architectural revivals. There were three main styles, or orders as they are known: Doric, Ionic, and Corinthian. The Doric order was the first, and it was derived from the wooden temples constructed by the early Greeks. It was an austere, yet dignified form, with a very simple capital at the top of its columns. The columns themselves were often fluted, or grooved, up the sides. The Parthenon in Athens is a good example of the Doric order.

The same basic form of lines of columns surmounted by a triangular pediment occurs with the other two orders, but the capitals of the later columns are more decorated, the Corinthian having so many leaves sprouting at the top as to actually suggest something that grew out of the ground.

Of all the Classical orders the Ionic is probably the most familiar to us, the most likely to come to mind when Greek or Roman temples are mentioned. The two distinctive spirals are an abstraction of plant growth. Ionic temples had their origins in Asia Minor, once a part of the Greek world, now the east coast of Turkey. The ancient Greeks prefered temples with clean mathematical lines—almost a parallel to the austere lines of the modern International Style. However, they also recognized the presence of the organic in architecture, and skillfully integrated the two. The spirals, or volutes, as they are known on Ionic capitals, are perhaps the purest expression of this. Spirals, flowers and leaves are found in the capitals of the Ionic and Corinthian orders. The ancient Greeks understood that the inspiration for columns came from trees.

The Corinthian order is the most orna-mental of the three Classical orders, with its small spirals resting on a bed of stylized acanthus leaves. There is an ancient Greek story concerning the origin of this style. It tells of a young Corinthian girl who died prematurely. After the burial her nurse placed her belongings in a basket and put them by the tomb with a weight on it to keep the contents from spilling out in the wind. She placed it over the roots of an acanthus plant which put out shoots shortly after. A Greek architect named Callima-chus passed by it and was enchanted with the two curling shoots at either end of the basket. They suggested the volutes of a stone capital to him, and he transposed them and the acanthus leaves to the top of a column. The ancient Romans used the Corinthian extensively, and it is the most frequently encountered Classical order in Vancouver and Victoria. Other Classical elements, such as the scallop, the caduceus, and urns, abound in this style.

Hidden Cities

Union Bank, Vancouver

Royal Bank, Vancouver

A fine Ionic temple bank stands at the corner of Seymour and Hastings Streets. Built 1919-20, and designed by Putnam and Somervell, it was originally known as the Union Bank. It became the Bank of Toronto in 1926, then finally the Toronto Dominion Bank in 1955. It had been slated for demolition, but the concerted efforts of a group of architects with a plan to renovate the existing structure, offers it some hope. This bank is a fine Second Renaissance design, rich in stone and terra cotta ornament. The destruction of these irreplacable links with thousands of years of history would be a tragedy.

Most of Vancouver's grand old temple banks are within a few blocks of each other in the central business district, but there are a couple of them in the Strathcona district as well. At 400 Main Street, by the junction with Hastings Street stands this gray granite Ionic-with-pine cones Royal Bank of Canada. While the Neo-Classical detailing on it is quite good, it is lacking the Bank's lion emblem, which was not conceived and developed until a later date.

There is a fine representation of the

Bank of Commerce, Vancouver

Ionic order at the corner of Granville and Hastings Streets. The Canadian Bank of Commerce was the first temple bank in the City of Vancouver and it continues to be a working bank. There is still a lot of beautiful marble on the walls inside, and, on the exterior, many examples of intricately carved granite scrollwork can be seen. It was designed by Darling and Pearson and built between 1906 and 1908. John Pearson would later be reponsible for rebuilding the Parliament Buildings in Ottawa, after the great fire of 1916.

Banks in Europe took their cue from Classical revivals which began with the Renaissance in Italy, and returned many times throughout the succeeding centuries. The solid and secure appearance of the Classical temple form, intended to reassure their clients of the safety of their finances appealed to banks, who appreciated the visual reinforcement of security in monumental stonework.

All of the Classical orders are well represented in Vancouver. The handful of wonderful temple banks in the downtown area are the most obvious place to look for them, but they are also part of other buildings where one might not expect to find them. Take the Lumberman's Building at 509 Seymour Street, for example. It has a beautiful row of pure Doric columns along its street-front façade. These columns might suggest a row of tree trunks, but the architect has paid a lot of attention to the classical model from which these are taken, in both the columns and their simple capitals, and

the small decorative details around them. This fine building went up in 1913, constructed by Charles Bentall as the North West Building.

These two columns at street level on the Sun Tower, at the corner of Vancouver's Beatty and West Pender Streets, are of the Doric order, though the capitals are slightly modified. The Sun Tower was built just before the First World War, and its tower is mainly a Beaux-Arts Classical Style building. It was designed by W.T. Whiteway for newspaper publisher Louis D. Taylor.

Bank of Commerce, Vancouver

Lumberman's Building, Vancouver

The Sun Tower, Vancouver

Page House, Vancouver

Merchants Bank, Vancouver

Currently known as Page House, this wonderful little Neo-Classical gem has paired Corinthian columns, and has been painted carefully to bring out its structure. Constructed as the B.C. Permanent Trust Building in 1907, it is the work of Victoria-based architects Hooper and Watkins. This is a perfect example of the Beaux-Arts Style, named for the French academy known as L'Ecole des Beaux Arts, a school which emphasized drawing as a way of visualizing architectural form. The building currently houses a jeweller's supply store.

At the corner of Hastings and Carrall Streets stands a fascinating building, home to Vancouver's Co-op Radio, and hundreds of pigeons. It was the first local branch of the Montreal-based Merchants Bank, designed by Somervell and Putnam, and constructed 1912-13.

One of the many finely wrought examples of stonecarving around this building are these Corinthian capitals with their peculiar six-pointed acanthus flowers, which look like motorized fans or tiny propellers.

Perhaps the most beautifully formed Corinthian columns in Vancouver are part of the Bank of Montreal at 580 Granville Street. Designed by the architects Putnam and Somervell and built 1915-16, it was later modified by Kenneth G. Rea in 1924. The finely carved acanthus leaves unfurl upwards like waves at a beach, towards tiny spiral volutes from which the acanthus flower opens. Like the building which houses Vancouver Co-op Radio, this was originally a Merchants Bank. It has been a Bank of Montreal since 1921.

Bank of Montreal, Vancouver

Near the end of West Hastings Street is the stylish Credit Foncier Bank. This could be the tallest of Vancouver's temple banks, though it really is an Edwardian Commercial Style building with its fancy copper roof cornice, and clear distinction between base and shaft. It has been detailed as a Corinthian order building, and has a row of columns with fine capitals on them. Below the cornice, towards the top of the building are these columns, albeit split by a more prosaic support. This fine building was designed by H.L. Stevens, and constructed in 1913-14.

The Bay, Vancouver

Credit Foncier Building, Vancouver

The Hudson's Bay Company was created over 320 years ago, and was a major force in opening Canada's frontiers. With the creation of Fort Langley in 1827, near present day Vancouver, and Fort Camosun in 1843, out of which would grow Victoria, the Hudson's Bay Company played a major role in European development of the North West Coast. Known as "The Bay" in its current incarnation, it still sells knives and blankets, just as it did 150 years ago, though animal pelts are no longer accepted as currency, and the range of goods available today is something out of the wilder dreams of those old frontier traders.

The Bay's department store at 674 Granville Street has a flavour of colonial architecture about it. Begun in 1913, it grew in four stages across a city block, to its completion in 1950. It was designed by Burke, Horwood and White, who createded here a model for similar cream-coloured buildings in Victoria, Calgary and Winnipeg.

The terra cotta columns that flank this graceful Edwardian edifice are a hybrid of the Corinthian and Egyptian Styles. Column after column soars up four storeys from the delicately ornamented base and fluted shafts to the acanthus leaves of the capitals.

Another familiar Classical motif is the urn. In our age it has been reduced to little more than an ornament in itself, but in ancient times this was a multi-purpose container used in all manner of activities. It was used to store everything from water and wine to meat and grains. The decorative use of the urn seems, however, to have come from its use as storage for crematorium ashes. The ashes and bones of the dead were stored in urns for burial in Greek and Roman times. In some cases the funerary urns of famous people were incorporated into monuments. The urns would then be made from carved stone instead of ceramic. Revivals of Classical orders brought the urn with them, but it seems unlikely that the connotations of death were intended; rather, the pleasing form of the

The Standard Building, Vancouver

urn became a part of the repertoire of decoration used by architects in their designs.

The Standard Building at 510 West Hastings Street is an eclectic structure with Neo-Gothic decoration around its top floors, and some curious Classical hybrids around the base. The urn was a favorite motif of the Greeks and Romans, and we see it here with a pair of Ionic spirals. The Standard was originally known as the Weart Building, and it was completed in 1913. At that time it was the tallest pure office block in the city, with 15 floors. The architects were Russell, Babcock and Rice. Urn forms can be seen among these other

strange decorative elements, which are just above street-level on the north face of the building.

At 119 West Pender Street, just up the hill from Vancouver's Chinatown, is the Shelley Building, decorated with a row of relief designs in glazed terra cotta, featuring flowers and these floating urn motifs. The building dates to the same period as the nearby Sun Tower, circa 1912.

Shelley Building, Vancouver

The Standard Building, Vancouver

Sinclair Centre, Vancouver

There are several nicely formed urns along the upper part of the old Chief Post Office of Vancouver, at the corner of Hastings and Granville, now part of the Sinclair Center. Designed and constructed by the Department of Public Works between 1905 and 1910, it is a blend of Beaux-Arts Classical and Edwardian styles, a fine, stately building with many interesting touches on its granite façade.

The façade of what is now the Vancouver Antique Centre, at the corner of Hastings and Richards Streets, has a very Roman appearance to it. Designed as the Bank of British Columbia by Victoria-based architect Thomas Sorby, it once had a row of arches along the lower level. It dates to 1889, making it almost as old as the City of Vancouver itself, and a perfect venue for the sale of antiquities. The urn placed above the arches gives it the look of a Classical temple, or one of the fantastic buildings carved from stone in the ancient city of Petra, in Jordan.

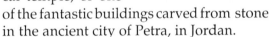
Antique Centre, Vancouver

by R.T Garrow. It remains to this day one of the most elegant hotels in the city.

On the Hotel Georgia one may see some other urn motifs. Though not as encrusted with imagery as its neighbor, the Hotel Vancouver, these urns filled with flowers beside the windows on one of the lower floors add a lively rhythm to the sides of the building. The Georgia dates from 1927, and was designed

Hotel Georgia, Vancouver

Sam the Record Man, Vancouver

This rather baroque-looking building at 568-72 Seymour in Vancouver, restored and owned by Sam the Record Man, was built as the Exchange Building in 1905. The architects were Baker, McGarva, and Hart. It has a row of exquisite scallops along the top. This delicious shellfish has been used since antiquity as a motif. A goddess, known as Aphrodite to the Greeks, and Venus to the Romans, was said to have risen from the bottom of the sea on a scallop shell. There are many Classical and Renaissance sculptures and paintings depicting this exotic birth of the goddess of love, such as Sandro Botticelli's painting called the "The Birth of Venus." The Romans were very fond of the scallop motif, and used it to decorate everything from wall niches in homes, to bottles and carved stone sarcophagi. The pleasing curve and ripple of the scallop shell lends itself easily to many aspects of design.

The Horne Block, Vancouver

The scallop and the sunburst are two very similar forms that can be called universal motifs. Every culture and civilization in the world uses some example of these lines radiating out from a central point.

The Horne Block, 311 West Cordova at Water Street in Gastown, displays a wonderful assortment of sunburst motifs. The architect was N.S. Hoffar, who was responsible for many buildings in the city after the great fire of 1886. He designed this long, narrow Victorian Italianate structure for land speculator J.W. Horne in 1889. There was once a tower at the top of the narrow end of the building, but it has long since disappeared.

The former Arts, Science and Technology Centre, at the corner of Dunsmuir and Granville, displays some varied scallop motifs. Originally the B.C. Hydro Electric Show Rooms, it was built in a rather eclectic style in 1928. The architects were Hodgson and Simmonds. This single and very graceful scallop motif is just below the roofline of the building on a long, narrow bronze relief. The other scallops are along the tops of the ornate window frames.

B.C. Electric Showrooms, Vancouver

B.C. Electric Showrooms, Vancouver

The Province Building, Vancouver

The Vancouver Province began as an independent newspaper, and the elegant building at 198 West Hastings Street was once the Province Building. Originally, upon its completion in 1909, it was known as the Carter-Cotton building, the home of the News-Advertiser newspaper. The News-Advertiser was absorbed later into the Vancouver Sun. There are several wonderful motifs on this smartly detailed structure, such as these delicately modelled scallop forms.

Hotel Europe, Vancouver

In Vancouver's Gastown there is a unique hotel built in 1909, and renovated in the late 1980's into individual suites. The Hotel Europe was designed by Parr and Fee for Angelo Colari. This hotel was modelled after New York City's "Flat-Iron" building, a tall, curved skyscraper which made good use of a narrow piece of land. A heavy cornice projecting from around the roof is also common to both. This carved granite scallop in a doughnut is evident at street level.

At 921 Government Street in Victoria is the Weiler Brothers' 1898 department store building. The designer was Thomas Sorby, one of the influential Five Sisters Block architects, and the Weiler Building is one of his finest designs. Two floors of huge arched windows provided dramatic showrooms for these thriving merchants. The carved stone details appear around the windows of the fourth floor, and include this scallop motif.

A delicately carved scallop tops the entrance to Ferrera Court, which is located at 504 East Hastings. This fine second Renaissance block bears a centennial plaque on it with the following text: "In 1922 Ferrera Court was the

Weiler Building, Victoria

home of Vancouver tailor David Marks, where vaudeville comedian Benny Kubelsky met thirteen-year old Sadie Marks. They dated in 1926 and married the next year. As Jack Benny and Mary Livingstone they often returned to the city of her birth."

Ferrera Court, Vancouver

Hidden Cities

Rithett Building, Victoria

nificance: awakening people from sleep, leading them to the underworld, and rescuing them from it. Wings representing the heaven of the Olympian gods, and serpents symbolizing the lower regions of Hades, point to the freedom of the messenger of the gods to go anywhere. This freedom of movement brought the association with travel, and this in turn led to an association with commerce.

The Rithett Building on Wharf Street in Victoria has a row of prefabricated iron caducei along the tops of the slender piers of its window bays. Actually a conglomeration of three buildings dating from 1861 to 1885, these Victorian Italianate façades mark the western edge of the original Hudson's Bay Company Fort.

it dates to 1911-12. The trams actually entered the building through the archways (now serving as windows) at street level.

The massive Edwardian Baroque Bank of Commerce at Main and Pender Streets

Bank of Commerce, Vancouver

Scholars have found the origins of the caduceus of Mercury among the Phoenicians, in parts of Asia Minor, and even the winged disk of the Egyptians was sometimes placed on a staff. It bears a resemblance to the staff of Aesculapius the healer, which is a plain staff with a single snake coiled around it, adopted by the medical profession as its emblem. The caduceus probably evolved from these various symbols. The two snakes wound around the staff make a perfect model for the D.N.A. molecule, the building block of life on earth.

The wand of Hermes had another sig-

The bank and office block embellished with these cast metal caducei was origi-

B.C. Electric Railway Building, Vancouver

nally Vancouver's B.C. Electric Railway Building. A Somervell and Putnam design,

has this caduceus neatly set at its peak, with two smaller ones flanking it at the sides. It was designed by architect V.D. Horsburgh, and built in 1915. Not yet dwarfed by skyscrapers like the old stone banks in the city centre, it remains a ponderous Main Street monument.

At the front of the Pemberton Building, at 744 West Hastings Street, are a couple of ceramic examples of the ancient herald's staff that seems so popular here on the West Coast. The glazed terra cotta ornament is a modest, but attractive part of this 1910 W.M. Somervell building.

Pemberton Building, Vancouver

The aforementioned Egyptian solar disk is used as a motif on the Victory Building, located at 319 West Pender Street in Vancouver.

Victory Building, Vancouver

Another distinctive feature of Classical architecture, the scroll was used by the Romans, and later used by Renaissance and Baroque architects. Closer to this age, it has been popular among classical revivals. A similar medallion scroll device crowns the cornice of the exclusive Vancouver Club in the heart of the city's financial district. The second Vancouver Club to be located on this site, it is a sharp-edged flamboyant scroll, executed in an almost Cubist manner. Located at 915 West Hastings Street, it was designed by Sharp and Thompson, and constructed between 1912 and 1914.

Along the sides of the Province Building, at 198 West Hastings Street, are these decorative scroll and leaf forms. There are some fine variations along the front of the building, and another on the cornice.

The Royal Trust at 1205 Government Street in Victoria has a couple of interesting examples of architectural decoration on its lower façade. This baroque flourish, mixed with floral and geometric motifs, is certainly a

Vancouver Club, Vancouver

tour de force. It rivals the scroll on the Royal Theatre for opulence.

Province Building, Vancouver

Royal Trust Building, Victoria

Part Eight

Heraldry & the Gothic

Heraldry as we know it began in the Middle Ages in Europe, when the insular units of feudalism began to respond to various influences, such as the Crusades and chivalry. Whenever two opposing parties fought at a tournament, or in battle, the knights would be completely enveloped in armour, their faces indistinguishable. Some means of distinction between the enemy and one's fellow knights and respective leaders was necessary. Colours, shapes and large, visible symbols made for quick identification, just as hockey uniforms or football sweaters make home viewing of team sports possible today.

The Crusaders made the journey to the Holy Land ostensibly to liberate it from the Saracens. Feudal lords had their shields painted with their family crests, while knights wore the same symbols on linen surcoats painted or embroidered over their armour (the "coat of arms"), and on the coverings for their horses. Over the passing of centuries these symbols and shapes were elaborated with the records of battles, deeds, and royal associations.

Where certain powerful families rose to pre-emince, their family shields became those of the states they controlled. Cities, as they achieved "free city" status, also devised a coat of arms for themselves with appropriate symbolism. Banks and large corporations have also followed suit.

During the age of feudalism a coat of arms could only be worn by members of noble, or titled families. This association with wealth and power made heraldry a mark of status, much like driving an expensive car today.

About the time of the Crusades, architects in France began the style which we know today as the Gothic. The dark, heavy, fortress-like churches of the Romanesque gave way to soaring, light-filled buildings, ornamented with flamboyant traceries and stained-glass windows. Archways and windows pushed towards heaven with the pointed ogival arch. These innovations spread to secular architecture, most notably to the palatial chateaux built for wealthy nobles. The style developed in Northern Europe before spreading south, and thus became known as the "Gothic," harking back to barbarian ancestors, in particular the Visigoths of France.

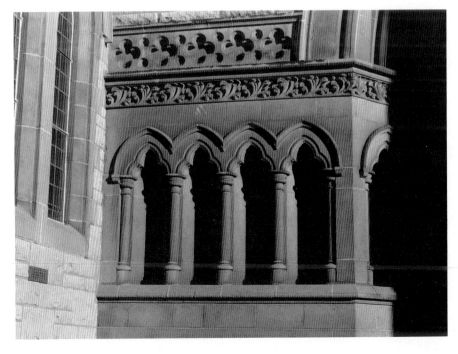

101

Both Vancouver and Victoria have some fine examples of Gothic revival architecture. The Gothic style waned with the spread of the Renaissance across Europe. Reactions to the Renaissance Neo-Classical, such as that of the Pre-Raphaelites, brought a renewed interest in the towers and traceries

Hotel Vancouver

of the Gothic mode. In America the towering heights of skyscrapers seemed to make them a natural subject for Gothic ornament.

While more Chateau-style than Skyscraper Gothic, the Hotel Vancouver clearly falls into the Gothic idiom. The Chateau-style was developed largely, as in this case, by the railways, but it soon came to be regarded as Canada's national style. The northern origins of the Gothic style were deemed appropriate for our country.

With its heavy-peaked mansard roof, many large gargoyles, and a plethora of imagery all over it, this grandest of the city's hotels positively reeks of the Middle Ages. All four sides of this building display fascinating stone carvings. Built between 1928 and 1939 (work slowed down a lot during the depression), it was designed by the architectural firm of Archibald and Schofield. These gargoyles were carved from Haddington Island granite, some blocks weighing over eight tons. The stone carvers came from all over Europe, as well as Mexico and Turkey. Many of the carvings are reproductions of 11th and 12th century European church carvings, while others are taken from more modern sources, such as printer's ornaments.

There are a several grand pieces of heraldry carved in stone on the Hotel Vancouver. Above the Hornby Street entrance you can see the B.C. coat of arms: British cross and setting sun,

framed with scrolls and floral motifs.

Above the main entrance on West Georgia is a true heraldic extravaganza. Again, we have the B.C. coat of arms, but here it is topped by an hourglass with a pair of wings, bison heads, and floral motifs. Flanked on one side by a steam train and on the other by an ocean liner, this imagery constitutes a visual paraphrasing of the original "By Land and Sea We Prosper" motto of the City of Vancouver. The City's growth was directly linked to the time saved in European trade with the Orient, made possible by the combination of ship and rail. The two bison heads mark the fact that the railway's long journey from the Pacific to the Great Lakes was mostly across the Prairies. A little below we find the winged head of Mercury.

Hotel Vancouver

Hotel Vancouver

Hidden Cities

At the busy corner of Granville and Broadway Streets there stands the Dick Building. The building is a fine, compact example of Commercial Gothic architecture. The quatrefoil detailing gives a faint trace of the organic to contrast with the harsh geometry of wires of all kinds that clutter this intersection. Built at the same time as the multicoloured Stock Exchange Building downtown (1929), the Dick features some similar polychrome terra cotta elements. The Gothic idiom is used here to good effect by Art Deco specialists Townley and Matheson.

The Dick Building, Vancouver

Burrard Bridge, Vancouver

In addition to his figures of Captains Burrard and Vancouver, this pair of brave colonial types represent more work by Vancouver sculptor Charles Marega on the 1933 Burrard Bridge. One is a logger, with his axe and a cut-down conifer beside him. His companion is a man of the sea with an oar and nets to balance the composition. Between them is a heavily stylized, yet still recognizable caduceus—Mercury's staff, an emblem of travel and commerce. Above it is the top of a suit of armour, which could signify either protection from harm, or conquest, and crowning it is a sea ship. This coat of arms for the City of Vancouver rests on the motto "By Land and Sea We Prosper." The city has since updated the official motto to read "By Land and Sea and Air We Prosper."

The Canadian Imperial Bank of Commerce, (known these days as the CIBC) has an administrative building next to the temple bank at Hastings and Granville Streets. Above the door is a wonderful mixture of heraldry executed in bronze: a long, narrow composition resolved with a central circular device. The Bank's coat of arms floats above the motto "Commerce, Industry, Integrity, Prudence" and is flanked by two pastorales of B.C. industry. To the left of the shield huge trees disapear into the sky, rolling clouds obscure towering mountains, while in the water a fishing trawler plys its nets. To the right are farm animals, a barn, and rows of planted crops, while a pipeline zigzags across a mountainside in the background. Between them a large industrial plant sends great plumes of smoke into the sky. Industrial optimism of the 1950's seems like black comedy to us in the lean, green 90's, but the wonderful execution of this intricate piece of heraldry deserves mention.

A coat of arms of a many-masted sailing ship below three sheaves of wheat appears in cast concrete on the side of the same building.

Bank of Commerce, Vancouver

Bank of Commerce, Vancouver

Bank of Commerce, Vancouver

Bank of Commerce, Vancouver

Hidden Cities

Toronto Dominion Bank, Vancouver

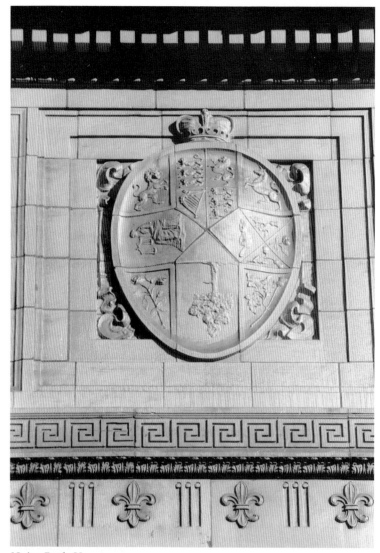

Union Bank, Vancouver

wick, British Columbia at the centre, and Manitoba, and ranged along the bottom: Prince Edward Island, Saskatchewan, Alberta, and Newfoundland. We see lions, bison, boats, fleur-de-lys, sheaves of wheat, sunsets, tall mountains, sailing ships, and maple leaves. Made from cast bronze, it is usually kept polished and gleaming.

The Bank of Toronto was created in 1856 by a group of Toronto merchants. It was amalgamated with the Dominion Bank in 1955.

Though it has been vacant for several years, the marvelous Second Renaissance temple bank at 580 West Hastings still has fine terra cotta coats of arms on the upper parts of its Hastings and Seymour façades. Arranged around an ovoid shield are British lions and roses, Scotish unicorns and thistles, and an Irish harp. There is a Canadian beaver, and a tree hanging upside down (well, it could be a Maple), and Madame Justice with her scales. This building began life as the Vancouver office of the Union Bank, which was taken over by the Bank of Toronto in 1926.

On Hastings Street at Pender Street in Vancouver one finds a Toronto Dominion Bank that displays the ten Provinces of Canada as represented by their respective coat of arms. From the top left are: Ontario, Quebec, and Nova Scotia, then New Bruns-

The old Central Post Office of Vancouver, presently known as the Sinclair Centre, has some beautiful flowing heraldry on it. The familiar B.C. emblem of British cross and the setting sun is seen here above a scrolling flourish.

Sinclair Centre, Vancouver

In an adjacent arched niche is a shield bearing a collection of familiar heraldic animals such as lions, fish, beavers, and bison, as well as thistles, fleur-de-lys, and trees. On closer inspection it reveals itelf to be the Canadian Provincial coats of arms. But there are only seven of them here. Ontario and Quebec take up almost half the shield along its top, while below it New Brunswick, Nova Scotia (the version of the coat of arms assigned the province at Confederation), and Manitoba take up the middle. B.C. and P.E.I. are reduced to visual acronyms along the bottom. Two of those absent from this shield, Alberta and Saskatchewan, did not join confederation as provinces until 1905, the year that work began on this building. Newfoundland was the last province to join, making Canada a nation coast to coast in 1949.

Completed in 1910 as the Federal Building by the Department of Public Works, its granite exterior and tall copper roof echoes a Europe of centuries past, sitting gracefully among the adjacent skyscrapers. There is a wealth of fine architectural detail on this building.

Sinclair Centre, Vancouver

Seymour Building, Vancouver

Seymour Building, Vancouver

Possibly the finest Gothic facade in Vancouver is on the Seymour Building. Located at 525 Seymour Street, this 1914 structure with its cream terra cotta facade is exquisitely detailed with trefoil ogival arches and stylized flowers. There are several small heraldic vignettes on it, including crowns, crossed keys and this barred drawbridge. It was originally known as the Yorkshire Building. The building was designed by Putnam and Somervell, who here departed from their classical predelictions, for the Yorkshire Guarantee and Security Company.

Outside Vancouver, at the corner of Columbia and Begbie Streets in downtown New Westminster, is a Bank of Nova Scotia featuring this coat of arms. It does not resemble the current Nova Scotian coat of arms, which is now similar to the original pre-Confederation coat of arms granted to the colony by the Crown. As one of the four founding Provinces that made up the first version of Canada, the Province of Nova Scotia was assigned a coat of arms by Royal decree in 1868. It was very similar to the one we see here, with an Atlantic Salmon in the middle, surrounded by numerous thistles.

For years the people of Nova Scotia complained and campaigned about this, and in 1929 the original 17th century crest was reinstated: a blue and white cross with a gold lion in its centre.

Bank of Nova Scotia, New Westminster

In downtown Vancouver are two fine skyscrapers with Skyscraper Gothic detailing on top. First we have the Standard Building at 510 West Hastings Street. It was the first real instance of Skyscraper Gothic in Vancouver, a handsome 15-storey structure, built in 1913. The original plans of the three architects, Russell, Babcock, and Rice called for a much more thorough treatment of the Gothic form than what was finally built.

At 475 Howe Street stands a fine 10-storey building which displays the Gothic touch from top to bottom, though the multi-coloured terra cotta decoration marks it as a contemporary of the Art Deco buildings which were appearing all over the city at that time. Constructed as Vancouver's second Stock Exchange Building in 1928-29, the architects were Townley and Matheson. It was a sign of the exuberant growth of the 1920's, but the "Crash of '29" saw many of the new tenants forced to leave or relocate to less expensive office space. The upper part of the building is definitely the finest part, with the Gothic embellishments at intervals giving the effect of crenellations on a medieval castle.

Standard Building, Vancouver

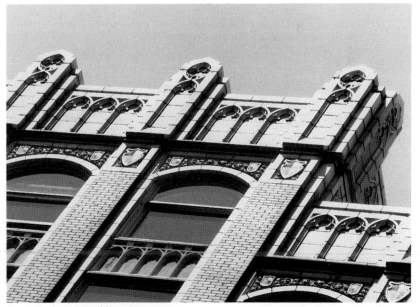

Stock Exchange Building, Vancouver

Hidden Cities

St. John the Divine Church, Victoria

The city of Victoria has nothing in the way of Skyscraper Gothic, but it in turn has a dozen or so wonderful Gothic churches. There are a number of them on Quadra Street, such as the Church of St. John the Divine, at 1611 Quadra. This is an Anglican church built in 1912, and the architect was Colonel William Ridgeway Wilson. The Hudson's Bay Company had bought the land where the previous Anglican church had stood, for their new store, and the proceeds paid for most of this red and white Gothic structure with its tall steep pitched spire.

At 951 Quadra Street is an Episcopalian church known as Christ Church Cathedral. It was designed by architect J.C. Malcolm Keith after an earlier style of Gothic, more

Christ Church, Victoria

in the manner of Notre Dame in Paris, and Durham Cathedral in Britain. It was completed in 1926, over 30 years after the initial design competition of 1891. This delay was no doubt to the considerable chagrin of the architect, as was probably the fact that his initial plans were not fully carried out. It is none the less an imposing structure, with

Christ Church, Victoria

its two symetrical stone towers, and the recessed stained glass window. There is a nice heraldic shield showing the keys of St. Peter, and a Bishop's curving staff, by the entrance on Quadra Street.

The most distinctive Neo-Gothic church in Vancouver is Holy Rosary Cathedral at the corner of Dunsmuir Street and Richards Street. Though it possesses little in the way of carved ornament, there are many Gothic touches, such as the carved stone ogival windows. The glowing stained glass windows inside are also impressive. The taller

of its two asymetric spires was once a city landmark — a reminder of the early settlement in what is now exclusively a commercial district. Built between 1899 and 1900 as a parish church, it became a cathedral in 1916. The architects were T.E. Julian and H.J. Williams.

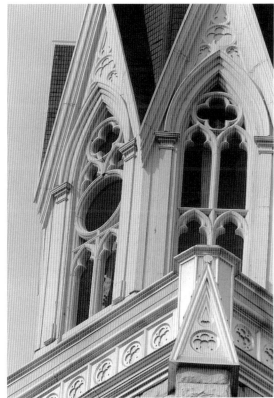

Holy Rosary Cathedral, Vancouver

The B.C. and Yukon Chamber of Mines, at 840 West Hastings Street, is a delightful little structure nestled among the skyscrapers of Vancouver's financial district. It glows in the late afternoon summer sun with a facade of cream terra cotta surfaces. Garnished along the top with a row of scallops,

the centre of the cornice features a shield bearing a crossed pick and shovel. The shield is surmounted by a crown and flanked by floral traceries.

At 2345 Main Street at 8th Avenue, situated in Vancouver's Mount Pleasant District, one finds a small, but finely wrought old bank building, which currently houses the Goh Ballet Academy. Above the Main Street entrance is a terra cotta arrangement of a crown, and sceptre, with a wreath of leaves. These symbols of royalty give us a clue — this was in fact once a Royal Bank. Designed by Thomas Hooper and built around 1914, it was in operation until the end of the 1960's. Like the branch at Main and Hastings Streets, there is no lion in evidence,

B.C. and Yukon Chamber of Mines, Vancouver

again pointing to this image being adopted by the Bank as a symbol at a later date.

Goh Ballet Academy, Vancouver

The Bay, Victoria

The Hudson's Bay Company coat of arms is seen here rendered in terra cotta outside a Victoria branch of this Canadian commercial institution. Various animals symbolizing the fur trade stand above the motto : "Pro Pelle Cutem."

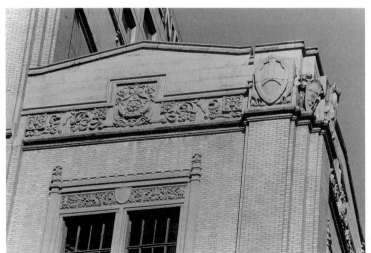
David Spencer Department Store, Vancouver

Formerly Eaton's, Sears, and now the downtown part of Simon Fraser University, this fine building at Vancouver's Harbour Centre has some interesting heraldic touches on it. It actually began as Spencer's Department Store in 1928. The architects were McCarter and Nairne. David Spencer's department stores were absorbed into the Eaton's chain in 1949. There is a lot of carved stone decoration on the exterior like this beast holding a shield.

Probably the most beautiful of all the many fine churches in Victoria is St. Andrew's Roman Catholic Cathedral at 840 View Street. It was built in 1892 with plans sent from the two Montreal architects, Perrault and Messiard, who designed it. Rich in Gothic ornament, its 72-foot high facade (facing onto Douglas Street) is crowned by a multi-coloured spire that rises to a height of 175 feet. The flamboyant traceries on the circular stained glass window are quite remarkable. This remains the largest church of any kind in Victoria.

St. Andrew's Cathedral, Victoria

Rattenbury's Chateau-Gothic gem on Victoria's Government Street is watched over by this pair of projecting gargoyles. This former Bank of Montreal remains one of his most striking creations.

Across from the Parliament Buildings stands Victoria's Empress Hotel, itself curiously devoid of much in the way of decora-

St. Andrew's Cathedral, Victoria

Bank of Montreal, Victoria

The Empress Hotel, Victoria

tive stone work. Designed by Rattenbury in the Chateau-style favoured by the Canadian Pacific Railways for their grand hotels across the country, the Empress remains one of Canada's finest. Two square stone pillars that mark the southwest entrance to the grounds of the Empress have imperial crowns carved in relief on them.

Part Nine
Art Deco

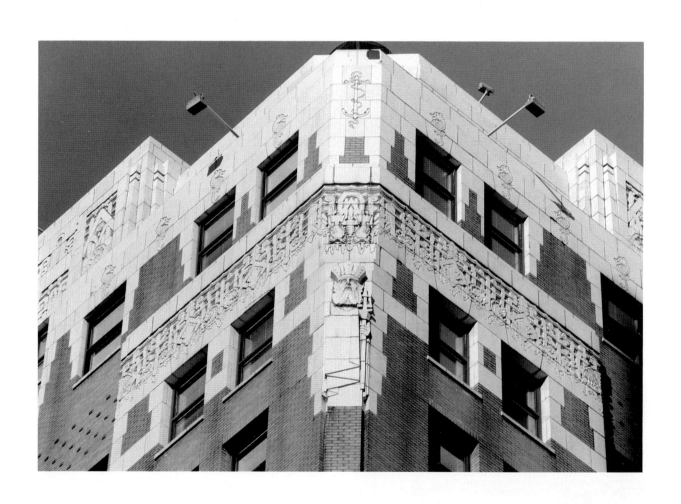

The source of the term Art Deco was a large show held in Paris in 1925 entitled: *L'Exposition des Arts Decoratifs et Industriels.* This seminal exhibition attempted to profile all of the most contemporary trends in both fine and applied arts, and architecture. The most progressive elements in this show paved the way for a completely new style. While Art Nouveau had been based on a sinous, flowing line, there were some designers and architects, such as Henry van de Veldt in Europe, and Frank Lloyd Wright in America, who had been experimenting during this period with more geometric styles which would become synonymous with Art Deco. Art Nouveau as an architectural style had made its strongest presence felt in Belgium and France, where the eccentric curves with floral and female motifs were successfully translated into buildings.

Towards the end of the 1920's and through the 1930's, a new, truly international style appeared. From New Zealand to America, and from Britain to Germany, streamlined forms with stylized decorative motifs appeared, a new and vibrant form to point the way to the future, which to the many who suffered the Great Depression of the 1930's, could only be a better future.

If Japanese art and design was a powerful influence on Art Nouveau, then the discovery and awareness of Pre-Columbian art and architecture was the greatest influence on Art Deco. Ancient Egyptian architecture, with its monumental forms and stylized decoration was another definite influence, but this form had been admired for centuries. Toltec, Aztec, and Mayan creations presented completely new forms. They were the subject of considerable interest and excitement as they were being discovered and uncovered by archeologists in the jungles of Mexico and Central America.

This was all happening at about the same time that North Americans were discovering that they could count themseves as a distinct and unique culture—there was no longer a need to look only to Europe for examples. The simplified, stylized forms of Mayan art with its bold lines and gently curved edges seemed to go together naturally with the streamlined forms of automobiles, ocean liners, trains, and aircraft. In addition, the stepped-back lines of Mayan temples seemed to lend themselves perfectly to the skyscraper.

115

Despite the fact that it is now surrounded by taller, newer, shinier office buildings, the Marine building still stands out with its classic skyscraper lines, and the profuse and beautiful terra cotta ornament that adorns its brick curtain walls from top to bottom. It is a well-cut gem set perfectly in relation to its theme, the sea and its wonders, with a prominent place at the intersection of Hastings and Burrard Streets, and a commanding view of the harbour.

This building was designed in the late 1920's by the firm McCarter and Nairne, and completed in late 1930. It was fortunate that it was built at all, construction taking place right at the start of the Depression. All the financial details must have been firmly in place. In any case, the unlucky developers, Toronto's Stimson Company, found themselves in difficulty soon after its completion. It cost $2,500,000 to build, and was sold in 1933 to the Guinness group for a good deal less.

The rich, cream coloured,

Marine Building

terra cotta decoration was designed by three architects employed by McCarter and Nairne: J. Watson, J.D. Hunter, and C. Young. They explored the marine theme from many different perspectives. Ocean flora and fauna, transportation, and an-

Marine Building, Vancouver

cient mythology all brilliantly set off the soaring skyscraper lines, and the stepped-back Mayan pyramid roof. The spirals, borrowed from Pre-Columbian stonework by the Art Deco movement, blend in here perfectly as the curling of waves and the eddying of ocean currents. When the three designers had completed their work, it was sent to the Seattle ceramics firm of Gladding, McBean to be executed in terra cotta.

The main entrance to the Marine Building should be ranked as one of the world's great masterpieces of the Art Deco Style. It

Marine Building

is certainly a *tour de force* of colour and texture, and it carries the oceanic theme of the building up through a vibrant panoply of flowing rhythms and movement opening outward. At its centre, with a bright setting sun, flocks of stylized geese are caught high in flight above a sailing vessel.

In addition to the the Marine Building's aquatic decoration is the parallel theme of transportation. Many different sea vessels are evident throughout the decorative scheme, such as in these smaller terra cotta cameos. Vancouver was built around the Pacific sea/rail connection, and trains are part of the transportation theme, seen here chugging along a mountainside covered with fir trees.

Marine Building

Marine Building

117

Marine Building

Marine Building

Marine Building

Marine Building

The revolving doors which sit at the base of the main entrance on Burrard Street are as richly decorated as any other part of the Marine Building.

In addition to the Art Deco spirals and geometric forms, the cast polished bronze doorframe is swimming with small sea creatures: snails, starfish, skate, crabs, turtles, carp, scallops, seaweed and seahorses.

Marine Building

Marine Building

Marine Building

Marine Building

Marine Building

Marine Building

Marine Building

An incredible richess of decoration is present here, notably the hemisphere of coloured panels which ring the archway of the main entrance, presenting a series of sea-bottom scenes, and the long friezes of sealife which run around the entire façade

Marine Building

Marine Building

Marine Building

Hidden Cities

Marine Building

The Marine Bulding has so much fine decoration on it that the eyes keep coming back for more. These wonderful motifs of sailing ships are two of many nautical images on the exterior.

Seabirds naturally feature as part of the watery ecosphere. Just above the revolving doors of the main entrance are these gleaming bronze seagulls with wings spread in the wind. This one clutches a writhing fish in its claws, while rippling waters splash below. The head and claws are modelled naturally, while the wings metamorphose from a realistic form to a more stylized Art Deco one, echoing the rays eminating from the bronze sunbursts above. Gracing the window directly above the main entrance is a pelican with outspread wings.

The designers made wonderful use of some of the corners of the building to create two tall, intricately composed pieces, one featuring the bow of a sailing ship, the other a stylized fish.

Marine Building

Marine Building

Marine Building

Marine Building

Marine Building

Hidden Cities

Marine Building

Bank of Commerce, Vancouver

Bank of Commerce

The cities of Vancouver and Victoria have a number of other interesting Art Deco structures within them, though there are no buildings which come close to the Marine Building for sheer grandeur of execution.

One of the earliest Art Deco buildings in the city has survived to this day under some protection as a Designated Heritage Façade. It began life as a Canadian Bank of Commerce, but it has been sitting vacant for about two years now.

Constructed in 1928, it was designed by the firm of Townley and Matheson. Their use of polychrome terra cotta across the façade gives the structure the look of a wedding-cake, a great act of faith in modern architecture for a bank at this time.

Bank of Commerce

Bank of Commerce

Cal-Van Truck Supplies, Vancouver

In Vancouver's Mount Pleasant district, located at 468 Kingsway, is a modest Art Deco structure currently occupied by the Cal-Van truck supply centre. Above the entrance are two identical motifs composed of the stylized spirals and ripples which often characterized the Art Deco Style.

Elesewhere in Vancouver is an interesting transition piece. Superficially a temple bank, its granite façade and slim columns are covered with lively Art Deco motifs. Replacing an earlier building across the street at 1200 Granville, the Bank of Nova Scotia at 1196 Granville Street (at Davie) was built in 1929. It was one of many new buildings in Vancouver that year to show the influence of Art Deco, which spread around the globe like a wave, in the late 1920's. The architects were Sharp and Thompson, who tried to give a progressive look to the surface while keeping the basic structure a traditional, conservative, Classical strongbox. The mixture of generally fussy Classical orders with bold, streamlined Art Deco is an uneasy one. The carved reliefs of stylized plant motifs are the most successful part of the facade, giving the plain granite a lively rhythm and variety.

Bank of Nova Scotia, Vancouver

Bank of Nova Scotia, Vancouver

Vogue Theatre, Vancouver

Vogue Theatre, Vancouver

The Vogue Theatre, constructed in 1940 for Vested Estates, was once a movie palace on upper Granville, and it was a favorite of Vancouverites up until 1988, when it closed its doors. The architects were Kaplan and Sprachman. The Vogue is a fine piece of Art Deco, as can be seen by these small motifs which occur just above street level, and the tall, stylish neon name-totem with its no longer glowing muse at the top. Actually, this 62-foot sign fin was originally capped by a 10-foot sheet metal figure, covered in gold leaf, of Diana, the Roman goddess of the hunt, designed by artist Lew Parry, and executed by Bud Graves. A neon copy replaced it in 1968. Diana was derived from the ancient Greek goddess Artemis, the twin sister of Apollo. Associated with moon worship, Artemis was a pure and chaste goddess, prone to harsh action at any infringement of her provenance. Once, a young Greek hunter was turned into a stag, and then devoured by his own hounds at Artemis' doing — all this simply because he chanced upon her while she was bathing.

A pawn shop at the corner of Granville and Nelson is one of several extant store fronts of one storey buildings from the early 1930's. These simple but satisfying Art Deco motifs which adorn them have been painted over with a coat of drably coloured paint making them almost invisible. They sit at eye level, but in the hustle, sleaze, and haze of lower downtown Granville Street, it is easy to pass right by them without a second glance.

Pawn Shop, Vancouver

Murrin Substation, Vancouver

Yet another piece of Art Deco by McCarter and Nairne, the Murrin Substation, was originally the B.C. Electric Railroad Substation. Located at 700 Main Street, near the Georgia viaduct, it is a big brick building without any windows. Over the doorways are these Art Deco concrete friezes of sunbursts. They are made of small tongues of flame and large lightning bolts, sources of power and electricity, and appropriate enough symbols for a power station.

Across the street from the old Stock Exchange is a fusion of old and new. The 1929 Hall Building of Northwood and Chivers has been fused with the newly adjacent Montreal Trust Building at 789 West Pender Street. The Hall Building's white stone façade has been given Gothic ornament around the very top of the building, but the lower part has many fine Art Deco motifs, such as this long incised frieze.

Hall Building, Vancouver

Sussex Building, Victoria

The Sussex Hotel, a fine building at 1001 Douglas Street in Victoria, is adorned with several identical glazed ceramic panels. It dates to the 1930's. These rhythmic abstract patterns suggest the waters of a fountain flowing through the air, a popular theme for Art Deco ornament.

Victoria's Tourist Information Bureau sits by the harbour at the intersection of Wharf and Government Streets. This small structure is a fine Art Deco gem. These abstract motifs are around the base of the tower which tops the building. Built as the Causeway Garage in 1931, the architects, Vancouver-based Townley and Matheson (designers of Vancouver's Art Deco City Hall) created a strikingly modern landmark for the city. The 80-foot beacon tower above the three-storey garage was built to encourage the use of Victoria's Inner Harbour for aviation, providing an aid to night landings. The original owner of the building was the Imperial Oil Company.

Vancouver City Hall

Vancouver City Hall, located at 435 West 12th Avenue, is one of the city's finest examples of Art Deco architecture. As designed by Townley and Matheson it was constructed between 1935 to 1936, at a cost of $2,000,000. The balance of horizontal and vertical elements present in the building, gracefully accomplished by means of the gradually rising stepped-back design, has kept this structure looking very up-to-date. There are two simple motifs employed around the building's exterior, both composed of a mixture of a wing and a spiral.

These motifs, found along the top of a one story Vancouver building on Seymour Street, just down from Dunsmuir, are similar to those on the Vogue Theatre. They appear to be made of a cast metal, and desperately need some repairs and new paint.

Tourist Information Centre, Victoria

Seymour Street store, Vancouver

129

Part Ten

Inner City Flora

Vancouver and Victoria are both garden cites, fortunate to have not only a variety of formal gardens in their midst, but also tree-lined streets and large natural reserves nearby. In addition, many examples of ceramic, carved stone and concrete vegetation are to be found on the older buildings within these cities. From acanthus leaves on Classical columns, to the floral interlace of Art Nouveau, there has always been a place in architecture for representations of the organic.

A city with no trees or bushes or flowers becomes a bleak and hostile place. The incorporation of sculptural representations of organic life provides a reminder of the clean air and open spaces missing from what is rapidly becoming a seamless environment of concrete, glass, and pavement.

The demands of developers for land will continue to erode our natural heritage, despite the best efforts of both conservationists and city planners. While many of the purely decorative motifs found upon the older styles of architecture were taken from organic sources. One wonders whether perhaps a revival of these forms of decoration will one day become a necessity.

Sinclair Centre, Vancouver

Sinclair Centre, Vancouver

finely balanced panels of radiating and spiraling plant forms. A few can be seen from the walkway, but the majority are a long way up, and only visible from a few vantage points, like the carpark across the street. These motifs enliven a facade which seems rather lacklustre next to the Beaux-Arts Classical Post Office.

Sinclair Centre, Vancouver

Part of the Sinclair Centre, along the Granville Street side, was originally an extension to the old Central Post Office and Federal Building. McCarter and Nairne, the architects who designed the Marine Building, were responsible for its design. It was constructed between 1935 and 1939, and opened by King George VI on a royal visit in 1939. Faced in limestone, it has some

In Vancouver's Gastown area four ornate capitals support Romanesque archways on a West Cordova Street façade. On the Water street façade of the same building, the stone archway of The International Academy, at 342 Water Street, two carved

capitals with sinuous shapes and spikey foliage are interwoven with an undulating ribbon. Stylistically, the interlaced leaves and spiralling or radiating movements come from Art Nouveau. Rows of relief buttons run along below the main motifs, and smaller intertwined leaves run above. The architect and designer of this building are unknown, but the style suggests either Vancouver architect William Blackmore, or one of the Five Sisters Block architects in Victoria.

Though the smaller capitals appear to be the same, a close look will reveal subtle

401-403 West Cordova Street, Vancouver

401-403 West Cordova Street, Vancouver

401-403 West Cordova Street, Vancouver

variations: like a musician improvising on a theme, the mason had the freedom to carve each piece uniquely. The pieces on this building were probably carved by one of the itinerant stonemasons who travelled about North America around the turn of the century.

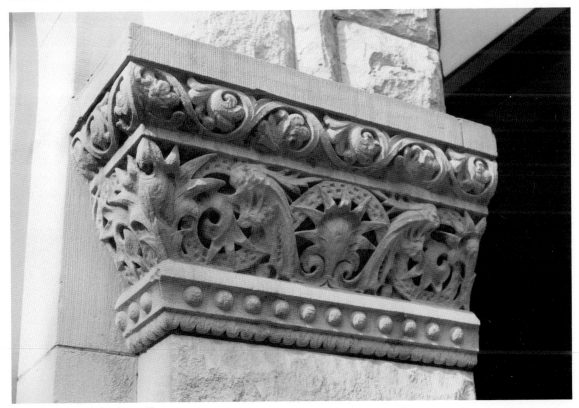

The International Academy, Vancouver

The large 1878 Masonic Lodge in Victoria at 650 Fisgard Street was designed by John Teague. It has a magnificent entrance with two large Corinthian columns surmounted by two large concrete orbs. The archway that frames the doors incorporates these capitals that suggest the Art Nouveau flora on the old Victoria Library, though the crumbling material reveals them to be concrete, rather than carved stone. A circular window glazed with the Star of David can be seen above the main entrance.

This lodge was a final statement of peace between two rival factions present in Victoria before B.C. joined confederation in 1870. One side wished to see the English rituals and traditions accepted in B.C., while the other, American-dominated faction, sought Scottish registry and ritual. The American faction petitioned England's Queen Victoria and U.S. President Grant to allow B.C. to become a part of the United States, a move which no doubt accelerated the eventual union with Canada.

Victoria's old Public Library has a flamboyant stone frieze of flowing plant forms beside its entrance. This product of Andrew

Carnegie Library, Victoria

Masonic Lodge, Victoria

Printer's Ornament

Masonic Lodge, Victoria

Carnegie's largesse dates back to 1906, contemporary with many similar examples of Art Nouveau-inspired stone carving. The library was designed by architects Hooper and Watkins in a Neo-Romanesque Style, which relates it to the Parliament buildings.

A delicate capital on a building on Johnson Street in Victoria incorporates a small scallop into the design. The leaves look like they could have come from a dandelion plant. This example is on one of the

buildings that fronts Victoria's Market Square, next to Thomas Hooper's 1891 Milne Building, and was probably designed by Hooper, or one of the other architects resident in the Five Sisters Block.

Johnson Street, Victoria

This small, flamboyant carving is to be found a way up the Smith, Davidson and Lecky Building, at 534 Yates Street. The big spikey-looking leaves suggest those of the globe artichoke plant. This building, constructed in 1900, was designed by Thomas Hooper as a warehouse for a wholesale grocer. Our current conception of a warehouse as a faceless bunker contrasts quite sharply with the Arts and Crafts qualities seen here. Decorative brickwork around the arched upper storey window, and a triangular gable at the top adorn this fine turn of the century building.

Lecky Building, Victoria

Along the second floor of this Government Street building are a series of capitals carved with interlace floral motifs. Built on the site formerly occupied by the New England Restaurant (which was renowned on the West Coast for its cuisine), the hotel that arose in its place in 1892 retained the name, applying it to the new restaurant inside. The New England Hotel was equally famous as a luxurious lodging, and was equiped with electric lighting and hot water in every room. It was designed by the Victoria architect John Teague.

Another, more stylized carving, can be seen by the entranceway to the Leiser Building at 524 Yates Street. There is a strong concern with rhythm and balance present

here. Like the previously mentioned floral carving, it embellishes a building designed as a warehouse for a wholesale grocery chain. Constructed in 1896, the architect was A. C. Ewart.

New England Hotel, Victoria

Leiser Building, Victoria

135

Take a look at this intricate stone carving on the exterior of the building now used by Vancouver Co-operatve Radio, at Hastings and Carrall Streets. The building was originally constructed for the Montreal based Merchants Bank (absorbed by the Bank of Montreal in 1921). It was constructed 1912-1913, the first branch in the city,

Merchants Bank, Vancouver

and the architects were Vancouver bank specialists Putnam and Somervell. The facade of the building, which curves gently around from Hastings Street to Carrall Street, was designed this way to allow the passage of C.P.R. trains, which formerly ran past the tree-shaded corner, popularly known as Pigeon Park.

These small repeating motifs of leaves and framed ovals occur along the base of a rather eclectic office tower. It stands at the south-west corner of West Pender and Homer Streets, at 402 West Pender. Constructed in 1912, the architect was H.S. Griffith. This is another of Vancouver's many surviving Edwardian Commercial buildings: the clear distinction between the base, middle and top make them easy to spot. As is usual with these buildings, there is a heavy cornice which projects from the roofline. The decoration on this building hints at the Classical, but has no real strong theme. It may have once been known as the West Pender Building (the former London Building two blocks west along Pender currently holds this title).

402 West Pender Street, Vancouver

At the foot of the south end of the Burrard Street Bridge is a unique building which is home to the 72 Battalion of Seaforth Highlanders. Known as the Seaforth Armories, this 1935 structure features turrets, stepped-gables, and narrow slits in the roofline, like those that archers in the Middle Ages once fired from. The architects were McCarter and Nairne, who, in a rare instance, looked outside of their own offices for someone to provide the artistic details on the façade. They chose noted sculptor Charles Marega, who created these sinous works based on an appropriately Scottish thistle motif.

Seaforth Armory, Vancouver

Parliament Buildings, Victoria

Flack Block, Vancouver

Capitals along the side of F.M. Rattenbury's Parliament Buildings in Victoria have many examples of carved vegetation on them, in addition to the many strange faces and gargoyles. They provide a good example of the wonderful marriage of creative imagination and fine craftsmanship which flourished in this city at the turn of the century. Like the carvings found on Romanesque churches in Europe, there is an abundance of variety present here.

A fine building in Vancouver, located at 163 West Hastings Street, at the corner of Cambie Street, has long window-columns capped by carved floral arabesques. Every one of these carved Art Nouveau flowerings is different. The row of Romanesque arches supported by these carved capitals is quite similar to those found on the Parliament Buildings. The Flack Block was built in 1899, and designed by architect William Blackmore. The original structure was graced by a magnificently carved archway around the entrance on Hastings Street, but it has sadly been destroyed and replaced by some very ordinary shopfronts.

The old Chief Post Office of Vancouver, now a part of the Sinclair Centre, has a few floral motifs towards the top of the clock tower. These small carved granite panels seem somewhat lost here, up high among the other details.

Sinclair Centre, Vancouver

137

In Vancouver's Gastown, granite has been coaxed into flowering by the fine hand of a stonemason, who carved several identical stone flowers. Originally the Gross and Co. Warehouse, it was constructed in 1909 after a design by Parr and Fee. Everything about this carving flows in harmony with its other parts. The white granite stone lends the

London Building, Vancouver

image a crisp texture. The building that they adorn is at 97 Water Street, where it intersects with Abbott Street.

Gross Warehouse, Vancouver

The 1912 London Building, at 626 West Pender Street in Vancouver, has several ornate floral decorations on its façade.

Pemberton Holmes Building, Victoria

The Pemberton Holmes Building on Government Street in Victoria is adorned

with a striking variety of images, few of them repeated, such as the rhythmic plant forms we see here.

The Temple Building, at 535 Fort Street in Victoria, is another structure brilliantly decorated with ceramics. The rich colour of terra cotta clay compliments the red brick used on the building. Among the detailed and fanciful works on it are several of the familiar spikey and interwoven plant-forms. As with the other works on the building, many of the carved stone leaves and flowers seen here echo the elaborate ornament used by the the American architect Louis Sullivan. His skyscrapers of the 1880's and 90's in the Eastern United States were highly influential. Although only a two-storey building, it is the only true example of this intricate style anywhere in B.C.

The Temple Building, Victoria

The Temple Building, Victoria

Hidden Cities

Carving strongly reminiscent of the decorative work found in medieval churches is evident on this ornamented stone column from Heritage House at 3102 Main Street in Vancouver. The organic forms of nature sprout from the hard inorganic matter of stone. Whatever extremes of difference the Gothic and the Classical may represent, here is a theme that runs under the surface of both these and many other architectural forms. Art Nouveau burst forth with it at the beginning of the century, but it seems to have disppeared from the current architectural vocabulary.

The monumental columns of the Bay department stores in Vancouver and Victoria are a glorious honeycomb of small floral motifs reaching skyward.

Climbing up the side of the entrance of the Medical Arts building is a lush ceramic foliage. A lot of this decoration has been covered by the signs of the various little shops that run along the front of the building between 823 and 829 Granville Street. It must have been quite a sight when the building was first opened, in 1923, as The Coughlan Building. The architect was Maurice Helyer, who designed it for Vancouver developer J.J. Coughlan.

Heritage Hall, Vancouver

The Bay, Vancouver

Medical Arts Building, Vancouver

At 805 Broughton Street in Victoria, the magnificent Royal Theatre has a truly regal amount of ceramic decoration on its façade: it exudes the luxury of a Roman villa. These repeating terra cotta tiles make a floral wreath around one of the entrances on the north side of this 1913 opera house and theatre. The architects Rochfort and Sankey looked to the Renaissance and Baroque architecture of Europe for inspiration in giving the building the kind of ornament appropriate for a Palace of the Arts.

Royal Theatre, Victoria

Temple Building, Victoria

Hidden Cities

Introductory Illustrations for:

Maps of the Cities

The maps included in the following section are provided to help the readers plan their own walking tours. There is a lot to look at in all of the areas covered here. Some structures, like the Parliament Buildings in Victoria, are so rich in imagery that hours can pass in examining the structure's countless details (especially since in this case, the interior is also accessible and fascinating). If you have the time, several small excursions might be more satisfying. Don't forget as well that there are other buildings to be explored which are not covered in this book.

Here are some points to consider when making your explorations.

1) Bring a pair of binoculars or a telescope.
2) Just look at one item at a time, and take breaks when looking at details which are a long way up. Your neck will thank you for it.
3) Be aware of the traffic when you are looking up and away from it.

The details on the majority of these buildings are visible from the street, but a few, like Hy's Steakhouse (Gabriola) in Vancouver are set back from the sidewalk. Though this restaurant is open to the public, it is not public property—please respect the privacy of others.

British Columbia Parliament Buildings

PARLIAMENT GROUNDS

1: Statue of Queen Victoria
2: Fountain
3: Entrance to Provincial Legislature
4: Captain Vancouver Statue
5: Library
6: Centennial Fountain
7: War Memorial Statue
8: Coast Salish Totem Pole

1: **The Provincial Legislature,** p. 42, 47-50, 63-65, 73, 137
2: **Madame Tussaud's** – 1117 Wharf Street, p. 83
3: **B.C. Provincial Museum** – 675 Belleville Street
4: **The Empress Hotel** – 921 Government Street, p. 113
5: **Statue of Captain Cook**
6: **Tourist Information Centre** – 812 Wharf Street, p. 129
7: **The Union Club of B.C.** – 805 Gordon Street, p. 87

LIBRARY STATUES

1: Colonel Moody
2: David Thompson
3: Sir Anthony Musgrave
4: Lord Lytton
5: Simon Fraser
6: Sir Alexander Mackenzie
7: Sir Francis Drake
8: Sir James Douglas
9: Captain James Cook
10: Dr. John Sebastian Helmcken
11: Dr. John McLoughlin
12: Sir Mathew Baillie Begbie
13: Captain George Vancouver
14: Chief Maquinna

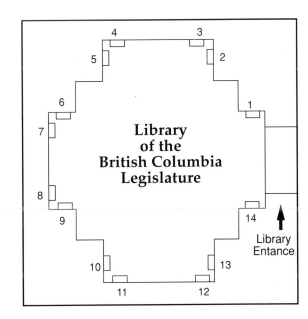

Library of the British Columbia Legislature

There are 14 statues by Charles Marega that crown the Library, all important figures in the history of British Columbia. There are also 6 medallions featuring great men of literature, appropriate for a library. There is Homer, Plato, Sophocles, Shakespeare, Dante and Milton. After you have seen all of these, make sure that you venture inside the building itself. It's up a few stairs, but the interior of the library has to be seen to be believed. Not only is the round central chamber opulent with marble, there is a circle of mythological beasts up above the room, and rich carving in the reading rooms.

Starting off at Government Street at Courtney Street is the Canada Customs Building with its colourful Royal Crest. At Government Street and Broughton Street are the Weiler and the Pemberton Holmes Buildings, kitty corner to each other. The Bank of B.C. Building at Fort Street makes a good contrast with the incredibly decorated Temple Building, just next to it. Around the corner is a small gem on Langley Street, a block away from the Rithett Building on Wharf Street. Up View to Government is the former Bank of Montreal and its gargoyles. Around and along Yates Street are three buildings worth checking out. A block over on Johnson Street is Market Square. Two blocks further up Government is Chinatown, you can't miss the beautiful Gate. Some distinctly Chinese looking buildings up Fisgard lead to the Masonic Temple at Douglas Street. Across from it is the Bay, and then up on Quadra is the Neo-Gothic church of St. John the Divine. Don't miss the old Public Library at Yates and Blanshard for its dragons, and floral carvings. The exquisite St. Andrew's Cathedral, a block up at View, has a colourful spire, and beautiful windows. On Fort Street, just down from Blanshard Street is the British American Trust Building. At Broughton and Douglas, across from the Art Deco Sussex Apartments. Up Broughton to Blanshard Street you can see the Royal Theatre, which has some magnificent decoration on its Broughton Street side. A block up on Quadra Street stands the fortress-like Anglican Christ Church Cathedral.

The Buildings

Downtown Vancouver Exploration

West Cordova Street

Burrard Street

West Hastings Street

West Pender Street

Hornby Street

Howe Street

Granville Street

Seymour Street

Richards Street

Homer Street

North

Dunsmuir Street

West Georgia Street

Robson Street

Starting at Burrard and Hastings Streets, at the Marine Building, head east to the Sinclair Centre where a turn north at Granville will bring you via a walkway up to The Station. Double back to Granville and Hastings for the Royal Tower and the temple bank across from it. Go around the Rogers Building then back up along Hastings, till you hit Sikora's music store. Then head back a block and go up Richards to Pender. There are a number of interesting sights along Pender to see before you check out the Seymour Building and Sam's on Seymour. Back on Granville at Pender you see the Bank of Montreal, then go up Granville. You can't miss the Bay's grand exterior, but the former B.C. Hydro showrooms and Kelly's need careful scrutiny. Across the street is the beautiful Art Deco facade of the former Bank of Commerce. Up along Robson to the Art Gallery with its lions all around, then up to Georgia to the hotel of the same name, and the adjacent Cathedral Square with its nurses. Across the street is the Hotel Vancouver, a fitting place to end your walk, and one that will keep your eyes busy for a long while!

The Buildings

Where the viaduct ends is the Art Deco Murrin Substation, and in the next block the Mandarin Centre with its strange ceramic fish up on the roof. Pender Street has a host of dragons lurking on it, and up around the corner at Main and Hastings are two temple banks and the Carnegie Centre. More dragons on Pender as you head towards the city, some of them up on the glazed roof-tiles of the Bank of Montreal. The Dr. Sun Yat Sen Gardens and the Chinese Cultural Centre are on the next block of Pender. After seeing the Holden Building on Hastings, the maidens of the Sun Tower await you, then see the Shelley Building across the street. Running from Pender Street up to Hastings Street are the connected Edgett and Province Buildings. Across the street is the ornate red splendour of Ormidale with its hidden faces, the adjacent Flack Block, and in the next block of Hastings is the Dominion Building. A block north takes you to West Cordova Street in Gastown for the Horne Block, and the dozen unique, yet unknown faces on Le Magasin The carved keystones of Pan on Darcy Murphy Fine Arts, and Medusa on the Water Street side of the same building are easy to spot. In the same block of Water Street are carved stone interlace fantasias with faces, animals and swirling forms on the Greenshields Building. There are many heritage buildings in Gastown which have interesting details worth hunting for. The cast-metal lamp posts found along Water Street, with their hidden animal heads, are also worth a look.

North

The Buildings

Mount Pleasant

In Vancouver's Mount Pleasant district we find many fine buildings showing noteworthy decoration. Firstly, on 5th Avenue, just east of Main Street, is the Native Education Centre, notable for its traditional West Coast Native styling, and the superbly carved Tsimsian housepole. Across Main, at 7th and Quebec is Quebec Manor with its caryatids, then at 2345 Main Street, at 8th Avenue, is the Goh Ballet Academy (formerly a Royal Bank), with a terra cotta crown and sceptre. Finally at 3102 Main Street is Heritage House with many hidden faces to find just below the roofline of the building.

Bibliography

American Art Nouveau,
Diane Chalmers Johnson, Harry N. Abrams, New York, 1979

Architecture as Nature,
Narciso G. Menocal, University of Wisconsin Press, 1981

The Architecture of John Wellborn Root,
Donald Hoffman, John Hopkins University Press, Baltimore, 1973

The British Columbia Parliament Buildings,
Martin Segger, Associated Resource Consultants, 1979

Canada: Symbols of Sovereignty,
Conrad Swan, University of Toronto Press (Undated)

China's Crafts,
Roberta H. Stalberg and Ruth Nesi, Eurasia Press, 1980

Chinese Lattice Designs,
Daniel Sheets Dye, Dover, New York, 1974

Chinese Symbols and Superstitions,
P. D. and Ione Perkins, Harry Titterton Morgan, 1942

City of Victoria Central Area Heritage Conservation Report,
City of Victoria Heritage Advisory Committee, 1977

Classical Mythology,
Mark Morford and Robert J. Lenardon, Longman, New York, 1977

Deco Delights,
Barbara Baer Capitman, E.P. Dutton, New York, 1988

Demons and Beasts in Art,
Diane Williams, Lerner Publications, Minneapolis, 1980

Exploring Vancouver Two,
Harold Kalman, University of British Columbia Press, 1978

Great Buildings of San Francisco,
Robert C. Bernhardi, Dover Publications, New York, 1980

A Guide to Art Nouveau Style,
William Hardy, Apple Press, London, 1986

Guide to Western Architecture,
John Gloag, George Allen and Unwin, London, 1958

Handbook of Chinese Art for Collectors and Students,
Margaret Medley, G. Bell and Sons, London, 1964

The Heraldry Book,
Marvin Grosswirth, Doubleday, New York, 1981

Heraldry Explained,
Arthur Charles Fox-Davies, Latimer Trend and Co, Devon, 1971

Listing of Potential Heritage Buildings,
Commonwealth Historic Resource Management Ltd. 1985

Living Architecture—the Romanesque,
Raymond Oursel, Oldbourne Book Company, London, 1967

Looking at Indian Art of the Northwest Coast,
Hilary Stewart, Douglas and Macintyre, 1979

Northwest Coast Indian Art, an Analysis of Form,
Bill Holm, University of Washington Press, 1965

A Pictorial Archive of Printer's Ornaments
Carole Belanger Grafton, Dover Publications, New York, 1980

The Pleasure of Seeing,
Gerald Formosa, Skorba, 1982

Public Art in Vancouver,
Doris C. Munroe, University of British Columbia, 1968

Rattenbury,
Terry Reksten, Sono Nis Press, Victoria, 1978

Samuel Maclure,
Martin Segger, Sono Nis Press, Victoria, 1986

The Scallop,
Ian Cox, editor, Shell Transport Co., 1957

Sea Otter Chiefs,
Michael P. Robinson, Friendly Cove Press, 1978

Selected Drawings, H. H. Richardson and his Office,
James F. O'Gorman, David R. Godine Press, Boston, 1974

Symbols, Signs, and their Meanings,
Arnold Whittick, Leonard Hill Books, London, 1960

Totem Poles,
Hilary Stewart, Douglas and Macintyre, 1990

Vancouver's Building Heritage,
Nancy E. Oliver, 1973

Vancouver's Heritage,
Vancouver Heritage Advisory Committee, 1974

Vancouver Heritage Inventory Summary Report,
Allen Parker and Associates, 1986

Vancouver's Past,
Raymond Hull, Gordon Soules, Christine Soules, Gordon Soules Economic and Marketing Research, 1974

Victoria, A Primer for Regional History in Architecture,
Martin Segger, American Life Foundation and Study Institute, 1979